HOLY TERRORS

GARGOYLES ON MEDIEVAL BUILDINGS

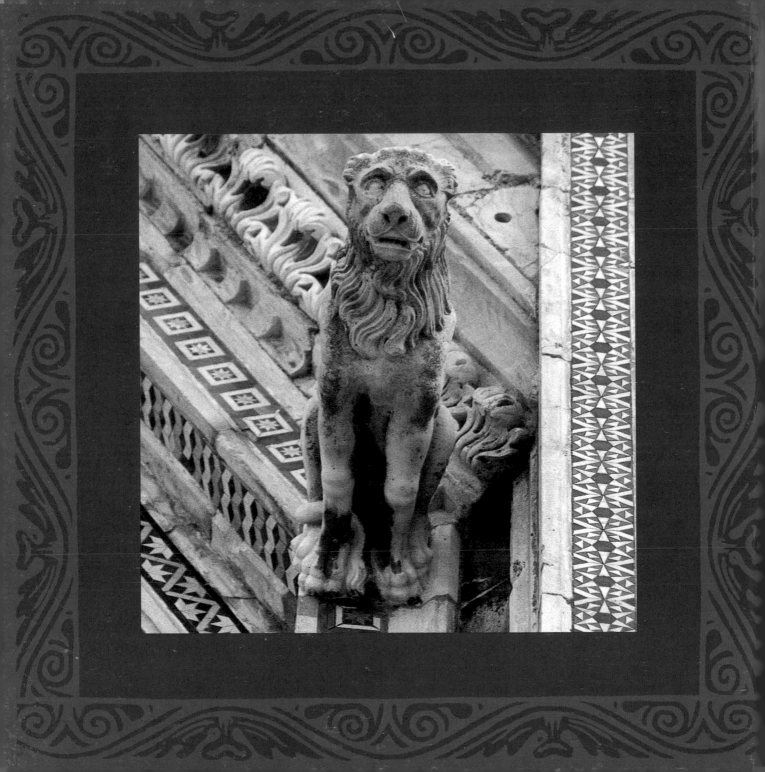

HOLY TERRORS

GARGOYLES ON MEDIEVAL BUILDINGS

JANETTA REBOLD BENTON

ABBEVILLE PRESS ❧ PUBLISHERS ❧ NEW YORK ❧ LONDON ❧ PARIS

FRONT COVER:
Mouth-puller imp, on balcony in courtyard, Hôtel de Sens, Paris.
BACK COVER:
Hairy human with animal head, Cathedral, Burgos, Spain.
FRONTISPIECE:
Lion, facade, Cathedral (Duomo), Orvieto, Italy.

EDITOR: Nancy Grubb
DESIGNER: Celia Fuller
PRODUCTION EDITOR: Susan McDonough
PRODUCTION MANAGER: Lou Bilka

First edition
2 4 6 8 10 9 7 5 3

Library of Congress Cataloging-in-Publication Data
Benton, Janetta Rebold,
Holy terrors : gargoyles on medieval buildings /
Janetta Rebold Benton.
p. cm.
Includes bibliographical references and index.
ISBN 0-7892-0182-8
1. Sculpture, Medieval. 2. Gargoyles—Europe. I. Title.
NB170.B46 1997
729'.5—dc20 96-36002

CONTENTS

INTRODUCTION

Some Facts and Some Conjectures about Gargoyles

Look up! Look out! A multitude of gargoyles haunt the medieval buildings of western Europe, peering down from churches and cathedrals, houses and town halls. Clinging to edges and ledges, these projections—carved of stone in the form of people, real animals, or fantastic beasts—mark rooflines, corners, and buttresses, enhancing the picturesque quality of a building's silhouette. When the sky is clear, gargoyles may merely glower from the towers—but do not stand below them on rainy days.

Gargoyles are elaborate waterspouts. Usually taking the form of an elongated fantastic animal, these decorated gutters are architectural necessities turned into ornament. To prevent rainwater from running down the masonry walls and eroding the mortar, water is carried a gargoyle's length away from the building and thrown clear of the wall. As can

1. *Gargoyle showing trough along back, courtyard, Hotel of the Catholic Kings (Hostal de los Reyes Católicos), Santiago de Compostela, Spain.*

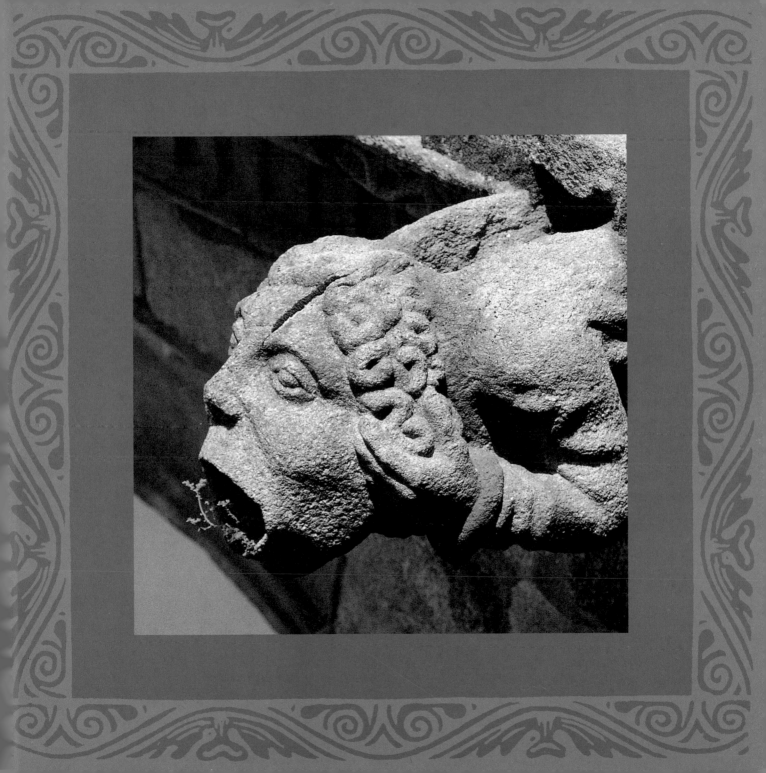

be seen by looking down at a gargoyle on the New Church in Delft, the Netherlands (plate 3), rainwater is removed from the roof via a trough cut in the back of the creature. The water usually exits through the open mouth, as demonstrated by a gargoyle in a courtyard of the Hotel of the Catholic Kings in Santiago de Compostela, Spain (plate 1). A sudden rainstorm in southern France provided an opportunity to photograph a functioning lion gargoyle as rainwater issued from its mouth on the Cathedral of Saint-Pierre et Saint-Paul in Troyes (plate 2). Rows of gargoyles—like those on the Cathedral of Notre-Dame in Paris (plate 6), positioned along the peripheries of buildings and extending out beyond their walls; and like those that surround a tower on the Town Hall of Bruges, Belgium (plate 4)—make clear their practical role as part of the drainage system. Water falling from gargoyles on the clerestory level of a church might, however, land

OPPOSITE: 2. *Working lion gargoyle after rain, south side, Cathedral of Saint-Pierre et Saint-Paul, Troyes, France.*

3. *Gargoyle showing trough along back, New Church (Nieuwekerk), Delft, the Netherlands.*

on the aisle roofs. When Gothic flying buttresses were used, aqueducts could be cut into the buttresses to divert the water over the aisle walls, as seen at Burgos Cathedral in Spain (plate 5).

Western European languages have many words to describe these architectural appendages. In Italian, *grónda sporgente*, an architecturally precise phrase, means "protruding gutter." The German *Wasserspeier* describes what the gargoyle appears to do; he is a "water spitter." The Dutch *waterspuwer*—"water spitter" or "water vomiter"—is similar. Different are the Spanish *gárgola* and the French *gargouille*, which come from the Latin *gargula*, meaning "gullet" or "throat." *Gargouille*, connected also with the French verb *gargariser*—which means "to gargle"—is surely the most evocative of these terms and is the source of the English word *gargoyle*. (A building may be described as *gargoyled*, which is to say, equipped with gargoyles.)

The term *gargoyle* has

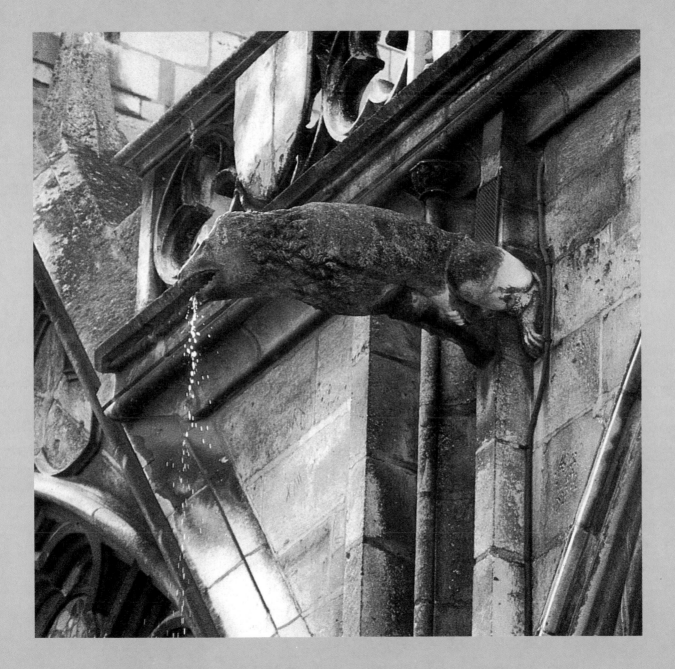

4. *Gargoyles on tower of Town Hall (Stadhuis), Bruges, Belgium.*

come to be applied, inaccurately, to other sculptures on the exteriors of medieval buildings that are similar to gargoyles in their grotesque anatomy but do not function as waterspouts. Strictly speaking, these are *grotesques* or *chimeras*. In the Middle Ages the term *babewyns*, derived from the Italian *babunio* (baboon), was used to refer not only to gargoyles but to any sort of grotesquerie. Today, given the toll taken by centuries of building alterations, modifications, weather, and pollution, it may be difficult to tell if water ever issued from certain medieval mouths.

The concept of a decorative projection through which water flows away from a building was known in antiquity. The architectural function of the gar-

5. *Flying buttress showing aqueduct with gargoyle at end, Cathedral, Burgos, Spain.*

did the Greeks, who especially favored the lion head. The Etruscans, too, used animal-shaped waterspouts. Lion-headed gargoyles and anthropomorphic waterspouts were frequent on homes in the Roman city of Pompeii, preserved by the eruption of the volcano Vesuvius in A.D. 79.

In the early Middle Ages, rainwater usually ran down the roofs and poured from the cornices directly onto the public streets. True gargoyles are thought to date from the beginning of the twelfth century. In the Gothic era, especially during the thirteenth century and thereafter, gargoyles became the preferred method of drainage. (Not all medieval waterspouts were carved as gargoyles, however. Even during the centuries when gargoyles were extremely popular, simple troughs might be used, particularly in areas of a building not exposed to view.)

An explanation, more charming than credible, for the gargoyle's name, ability to spout water, and physical form is found in the following tale. A dragon called La Gargouille—described as having a long, reptilian neck, a slender snout and jaws, heavy brows, and membranous wings—lived in a cave close to the River Seine in France. It had several bad habits: swallowing ships, causing destruction with its fiery breath, and spouting so much water that it caused flooding. The residents of nearby Rouen attempted to placate La Gargouille with an annual offering of a

goyles may originally have been served by wood or ceramic waterspouts; with the introduction of stone, the possibility of carving these protrusions into ornamental forms became more inviting. The ancient Egyptians used animal-shaped stone waterspouts, as

live victim; although the dragon preferred maidens, it was usually given a criminal to consume.

In the year 520, or perhaps around 600, the priest Romanus (or Romain) arrived in Rouen and promised to deal with the dragon if the townspeople agreed to be baptized and to build a church. Equipped with the annual convict and the items needed for an exorcism (bell, book, candle, and cross), Romanus subdued the dragon by making the sign of the cross and led the now docile beast back to town on a leash made from his priest's robe. When La Gargouille was burned at the stake, the head and neck, well tempered by the heat of the dragon's fiery breath, would not burn. These remnants were mounted on the town wall and became the model for gargoyles for centuries to come.

Although gargoyles can rarely be dated with certainty, they appear to have evolved in physical form over the years.[1] Believed to be among the earliest Gothic examples are the gargoyles at Laon Cathedral in France, of c. 1220, which are large in size but stubby in shape, little more than bust-length creatures, and few in number. Soon after, full-length gargoyles appeared on Notre-Dame in Paris, although still fairly short in their proportions. Those placed at

6. Row of gargoyles, north side, Cathedral of Notre-Dame, Paris.

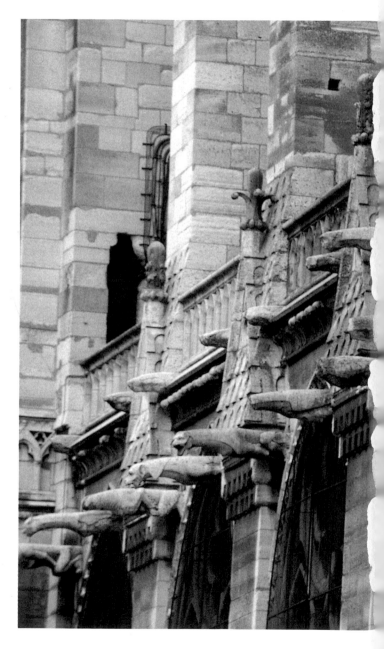

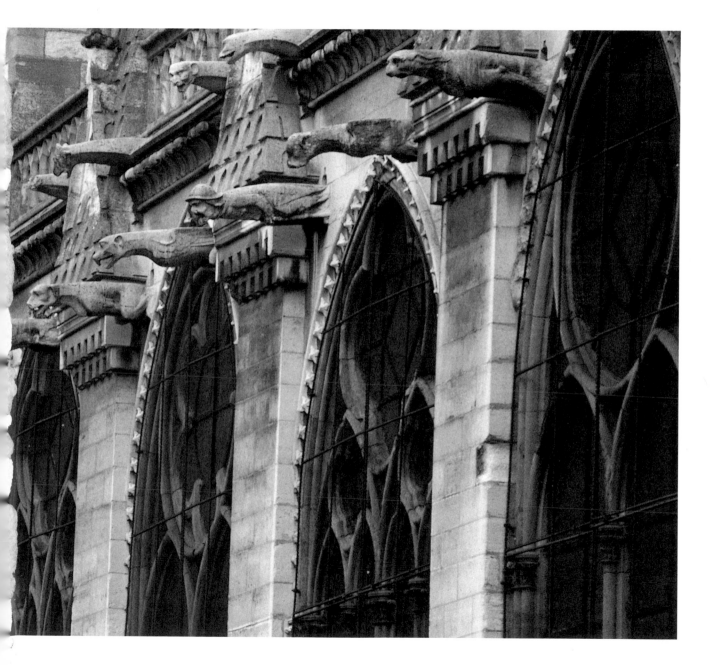

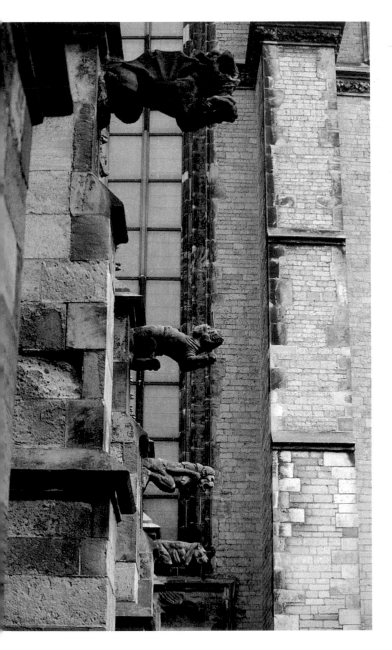

the ends of the canals of the flying buttresses on the nave of Notre-Dame were already longer in shape (plate 6). Once the entire animal was depicted, it was likely to be posed as if holding onto the building by its claws, establishing a logical and clever relationship between the animal and the architecture—a witty use of context that treats the animals as if real. These animals seem to stretch their bodies, and especially necks, as if trying to throw their water as far as possible from the building. Because architects quickly recognized that dividing the flow of water minimized the potential damage from each little trickle, gargoyles became widespread and were employed systematically before mid-century.

The gargoyles on early Gothic buildings might be crudely carved, but as gargoyles proliferated, the carving became finer and they gradually became works of art. Many are masterpieces of sculpture, the inventive efforts of highly skilled carvers working with energetic and expressive imagery—sometimes intentionally horrible, sometimes merely grotesque, sometimes humorous, but rarely pretty. In general, art of the Gothic era (mid-twelfth through fifteenth century), the high point of gargoyle production, can be said to be more realistic, refined, and graceful

7. *Gargoyles, cloister beside Old Cathedral (Domkerk), Utrecht, the Netherlands.*

than the art of the preceding Romanesque era (eleventh and twelfth centuries)—with the exception of Gothic gargoyles, which seem to perpetuate the characteristically Romanesque fascination with grotesque and monstrous creatures.[2]

8. *Gargoyles atop Cathedral of Notre-Dame, Paris.*

Toward the end of the thirteenth century gargoyles became more complicated and human figures tended to replace animals as gargoyles, as seen on the facade of Poitiers Cathedral in France (plates 45 and 46). From the end of the thirteenth century on, gargoyles became more exaggerated and caricatured, as well as increasingly elongated. During the fourteenth century, gargoyles were generally long and slender and often charged with details, as seen on the Schöner Brunnen Fountain in Nuremberg, built c. 1385–96 (plate 75). By the fifteenth century, gargoyles had become less demonic, made more amusing through energetic and exaggerated poses and facial expression, as seen in the courtyard of the House of Jacques Coeur, built 1443–51 (plate 14). As late Gothic sculpture came to include ever more nonreligious subjects, gargoyles,

too, seem to have lost some of their religious connotations, becoming more comical, with their former malice minimized. The inclusion of gargoyles on buildings continued into the sixteenth century, having been adopted throughout western Europe.

Rarely is a gargoyle found in isolation. Rather, they are almost always arranged in rows or clusters; their function accounts for their seemingly gregarious nature. In the cloister beside the Old Cathedral of Utrecht, the Netherlands, you are surrounded by gargoyles (plate 7). Everywhere you look at Notre-Dame in Paris, a creature seems to pop out (plate 8). At York Minster in England the shadows are full of faces (plate 9). If you glance up to the tower of the Gruuthusemuseum (formerly a residence, built in the fifteenth century) in Bruges, you may sense the scrutiny of a number of gargoyles (plate 10). These examples are only a sampling—throughout medieval western Europe, in cloisters, on churches and cathedrals, on homes, and elsewhere, there once existed an enormous population of gargoyles, a sort of society of stone people,

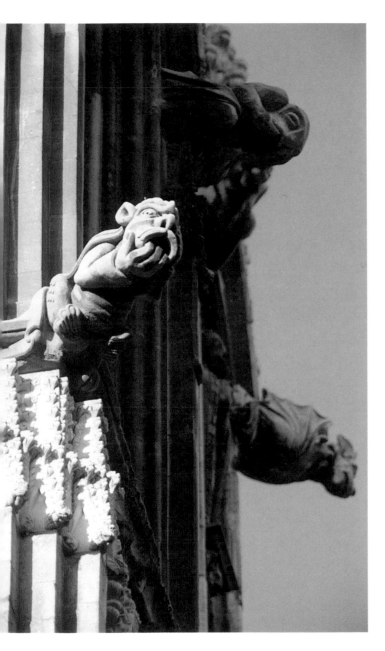

animals, and monsters living in an aerial environment. Hundreds of gargoyles can still be seen today.

Gargoyles were not likely to be carved *in situ* by sculptors precariously perched high on cathedral roofs, dropping pieces of stone onto the pavement and people below. Like other architectural sculptures, gargoyles usually were carved down on the ground (in the yard in good weather or indoors in the studio all year long) and installed in warm weather. But some medieval gargoyles may have been carved in place, as is done with architectural sculpture today, if some portion of the design would risk damage in the hoisting process or if the gargoyle block had to be inserted at a specific point in the construction, even if unfinished, to avoid delay. The visible figure of the gargoyle is only part of a large block (most of which cannot be seen once it is in place) that functions as a counterbalance, stabilizing the heavy stone figure extending out into space.

It is likely that medieval gargoyle carvers followed essentially the same procedures as sculptors do today, using hand tools much like those still in use—mallet, chisel, file, and calipers (to measure)—and developing their ideas by making one or more models in clay or plaster before carving the stone. A

9. Group of gargoyles, *south side, Minster (Cathedral Church of Saint Peter), York, England.*

medieval sculptor would rough out the basic form of the gargoyle from the stone block and then proceed to the more careful carving. Abrasion with a chisel refined the forms and created a surface that would protect the stone during the several years necessary for cut stone to harden. Since small-scale work and details would not be visible to the viewer far below, shapes were of necessity large and clear, deeply undercut to create shadows, with features and expression often exaggerated to the point of caricature.

Finally, the gargoyle, likely to weigh several hundred pounds, was carefully hoisted into position. Heavy scaffolding was not used in the Middle Ages, and cranes were not far-reaching. In the thirteenth century, when buildings began to be constructed of stones too heavy to carry by hand, the main device used for hoisting was the windlass and pulley, which could lift only vertically. Once the gargoyle was in place, its sculptor might recarve or touch up portions, for only then could the actual effect be assessed.

Some medieval gargoyles have short iron or lead pipes protruding from their mouths, as seen on the Parish Church of Thaxted, England (plate 11). Long cast-iron pipes, however, were not made during the Middle Ages, and those seen today are later additions—for example, on the Parish Church of Saint Andrew in Heckington, England (plate 12). As modern drainpipes have been installed, old gargoyles have

10. Gargoyles on tower of Gruuthusemuseum, Bruges, Belgium.

found themselves out of work. Few of the numerous gargoyles at Oxford University, for example, are still productively employed. When drainpipes were put in place, as on the chapel of Oxford's Merton College, the mouths of the gargoyles were plugged with concrete (these gargoyles, in fact, no longer survive at all).

Most medieval gargoyles were made of limestone or marble, but a few rare examples were made of metal, such as those of lead on Reims Cathedral in France, which date after a fire of 1481.[3] Lead gargoyles are more common from the sixteenth century forward, and some excellent nineteenth-century metal gargoyles inhabit the courtyard of the 1443 Hôtel

Dieu in Beaune, France. No terracotta examples survive from the Middle Ages. Brick was not used for gargoyles; even brick buildings have stone gargoyles.

The function of gargoyles as water channels and their protruding position on the exteriors of buildings make gargoyles especially vulnerable to erosion, decay, and damage. The type of stone used does much to determine a gargoyle's life span, but none can survive indefinitely. Airborne chemicals, especially in cities, slowly eat the stone, which is discolored by particles of pollution in the air and rain. Industrial pollutants combine in the air with water vapor to form acid rain, which speeds the process by dissolving minerals and thereby weakening the stone. The channels in the backs of the gargoyles tend to fill with dirt that, well watered, encourages the growth of plants whose roots cause additional damage (plate 1).

11. *Gargoyle with short metal pipe in mouth, north facade, Parish Church, Thaxted, England.*

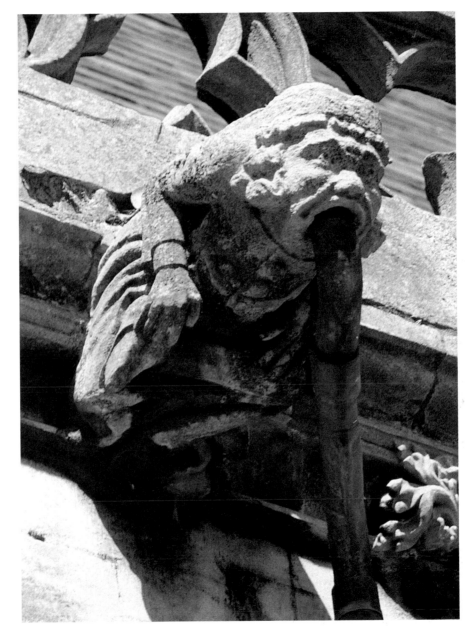

12. Gargoyle with long
modern metal pipe in mouth,
Parish Church of Saint Andrew,
Heckington, England.

Pigeons and other birds, evidently finding gargoyles to be comfortable perches, do their own kind of damage (plate 77). And people feel compelled to toss coins into the gargoyles within their range; if they are making a wish, perhaps it should be for the gargoyles' longevity. As the gargoyles gradually disintegrate, an arm, a head, or some other part may drop off—with significant danger to people below.

Many gargoyles on medieval buildings are not of genuine medieval manufacture, though it is often difficult, if not impossible, to visually distinguish the modern from the medieval.[4] Many gargoyles have undergone various degrees of repair, restoration, conservation, and reconstruction, while others are completely modern fabrications. Some overtly and obviously modern gargoyles are easy to identify, such as those of postmedieval individuals or of animals not known in western Europe during the Middle Ages, such as the rhinoceros and hippopotamus at Laon Cathedral (plates 13 and 106). Among

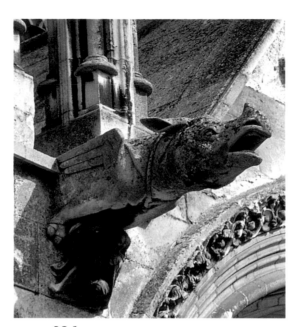

13. *Winged rhinoceros, west facade, Cathedral of Notre-Dame, Laon, France.*

the most frequently photographed of all gargoyles are those on Notre-Dame in Paris. Some of these sculptures were remade (using medieval models) under the direction of Eugène Emmanuel Viollet-le-Duc, who worked on Notre-Dame from 1845 to 1864. His work includes the balustrade figures, which, although they never spouted water, are routinely called gargoyles.

Lost today are the bright colors and gilding on medieval sculptures, including gargoyles and grotesques. Oranges, reds, and greens were favored—perhaps such combinations would be considered garish today. Now it is possible only to imagine how much more dramatic and emphatic the original effect must have been. But paint on exterior sculpture, especially that on gargoyles, which are so completely exposed to the elements, does not last long. What little exterior paint might have managed to survive was likely removed or repainted in the nineteenth-century wave of restoration work done to medieval buildings.

Even though the functional role of a waterspout would have been served quite as well by a simple half-cylinder, gargoyles became an art form. Concentrating such creativity on waterspouts could be considered a waste not just of time and money but also of aesthetic expression. For although some gargoyles are within easy viewing distance, a great many more are not. The ordinary earthbound visitors of the Middle Ages, few of whom even had eyeglasses, would not have been able to see many of the gargoyles. (Today's viewer can benefit from the illusion of proximity produced by field glasses, and the armchair traveler studying gargoyles via illustrations in books and journals is served by the capabilities of photographers' telephoto lenses.)

Given their often visually obscured or even inaccessible locations, why was so much artistic attention lavished on gargoyles? It is reasonable to suspect that gargoyles were more than merely functional decorations, but the meaning of gargoyles has long posed a problem and remains unclear. Among the great many gargoyles on medieval buildings, no two are alike—an extraordinary demonstration of the inventive imagination of the sculptors of the Middle Ages—and gargoyles may well have been almost as varied in significance as they were in form. Extant original documents offer little help in deciphering their significance.

Current confusion about the symbolism of gargoyles may result from the medieval acceptance of, or even preference for, layered and often conflicting meanings. The medieval affection for ambiguity allowed for a multiplicity of meanings that were neither black nor white; gray, too, was enjoyed and complexity encouraged. Careful analysis of the visible was believed to yield greater understanding of the invisible. Characteristic of the medieval mentality was a willingness to freely interpret reality, as well as fantasy, according to religious symbolism. Interpretation of a single animal (or plant, object, color, shape, number, season, person, and so on) often changed greatly, usually according to context. Further, the importance of symbolism, itself, varied.[5]

The fact that gargoyles are so varied and so fanciful argues against their use as educational devices. To function didactically, visual imagery must be readily intelligible. This necessity is the mother not of invention but of convention; repetition encourages recognition. Although a label could have explained the meaning of a unique image to the literate, the written word was unintelligible to most people living in medieval western Europe, including some of the clergy. Arguing against the possibility that all gargoyles were intended for the religious education of the public, or even of a select group within the Church hierarchy, is the fact that gargoyles also appear on secular edifices (plate 75) and on private homes (plate 14). Further

arguing against a symbolic interpretation of gargoyles is the apparent absence of a significant number of gargoyles in the forms of the standard repertoire of people and animals, real or imaginary, that appear so often in medieval art specifically for their iconographic connotations.

A now famous complaint against animals as ornament in churches was made in 1125 by Bernard of Clairvaux, founder of the austere Cistercian order:

In the cloister, before the eyes of the brothers while they read—what is that ridiculous monstrosity doing, an amazing kind of deformed beauty and yet a beautiful deformity? What are the filthy apes doing there? The fierce lions? The monstrous centaurs? The creatures, part man and part beast? The striped tigers? The fighting soldiers? The hunters blowing horns? You may see many bodies under one head, and conversely many heads on

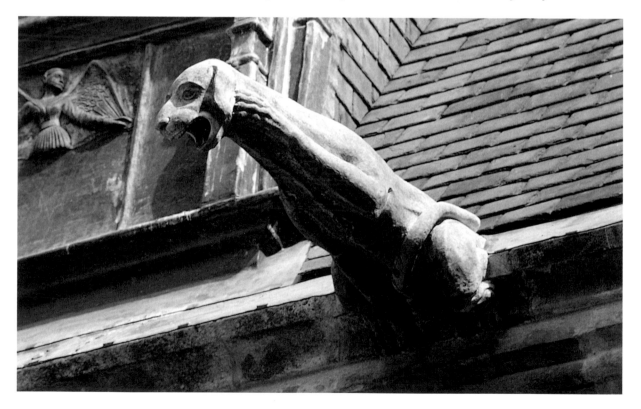

14. Dog, courtyard, House of Jacques Coeur, Bourges, France.

one body. On one side the tail of a serpent is seen on a quadruped, on the other side the head of a quadruped is on the body of a fish. Over there an animal has a horse for the front half and a goat for the back; here a creature which is horned in front is equine behind.[6]

Since Bernard scorned the grotesque creatures in the cloister as diversions from serious religious concerns, it is improbable that he would have liked them any better on the roof. Fortunately, Bernard's opinion, however eloquently expressed, seems not to have represented that of the majority.

Gargoyles could not have been created without the knowledge of ecclesiastics and patrons. Usually carved down at ground level alongside other church sculptures, gargoyles would have been equally as visible to the clergy, who were surely aware of the art they funded. Had these images been objectionable to the Church, they would have been removed long ago.

Sculptors who carved grotesque gargoyles may have found visual inspiration in the costumes of monsters with fur, horns, claws, and tails worn in mystery plays, in holiday celebrations such as the Feast of Fools, and in street processions on feast days. More visceral inspiration may have come from images passed down in ancient fireside tales—ancestral memories of a world of the past. Like medieval gro-

tesque art in general, gargoyles may be survivals of pagan beliefs the Church permitted to persist beside Christian subjects, incorporated into church decoration for superstitious reasons. Pope Gregory's instructions to Saint Augustine of Canterbury (d. 604) on how to convert pagans to Christianity specify that pagan buildings should be retained as places of Christian worship but with the idols replaced by relics; sacrificial cattle were still to be slain, but for a meal in God's honor rather than as pagan offerings. Tolerance of such pre-Christian structures and customs was permitted, and their perpetuation in modified form was accepted by the Church because of their value as aids in religious conversion.

It is possible that members of the medieval Church recognized the potential of gargoyles to intrigue, to entice, to attract attention—and perhaps even attendance. The medieval preference for grotesque gargoyles is clear; they far outnumber the comparatively few realistic depictions of humans or animals. The frequently monstrous nature of gargoyles makes obvious that all medieval art was not intended to be beautiful. In fact, ugliness had a fascination all its own, and images of the macabre were very much a part of daily life in the Middle Ages.

Because it is extremely unlikely that there is one meaning for all gargoyles, various interpretations must be surveyed. Some are of limited plausibility, such as

the suggestion that gargoyles were inspired by the excavations of skeletal remains of dinosaurs and prehistoric beasts, or that gargoyles were derived from the constellations.[7] Rather, the key that unlocks all discussion about the meaning of gargoyles seems to be the great concerns about sin and salvation that prevailed during the Middle Ages. The preoccupation of many medieval Christians with the eternal fate of their souls, coupled with widespread illiteracy and the consequent emphasis on the instructional use of visual imagery, resulted in the creation of many monsters in medieval art. Evil was both an abstract idea and a concrete fact—something very real that could be given visual form by artists.

It is likely that the frightening nature of gargoyles was partly due to the medieval artist's responsibility to help mold public behavior through intimidating images. For example, the "weighing of the souls" at the Last Judgment was frequently depicted in art, as was the "mouth of hell," routinely portrayed as the open jaws of a monstrous animal. As seen in the Limbourg brothers' depiction of hell (plate 15)—a full-page illumination in the sumptuous manuscript made for Jean, duke of Berry—the physical torments that would punish sinners were depicted as vividly as possible. Satan, as king of hell, is shown enjoying his bed of coals and, as described in the popular *Visions of Tondal* (originally written in

the twelfth century), he inhales and exhales the damned. Demons fan the flames with bellows and prod the burning bodies. Viewers were strongly encouraged to contemplate the results of their own sinful behavior; it was said in the Middle Ages that if love of God did not deter people from sin, then maybe fear of hell would.

Perhaps grotesque gargoyles were intended as guardians of the church, magic signs to ward off the devil. Amalgamations of animals have long been used by artists and authors to create frightening images. This interpretation would justify making a gargoyle as ugly as possible, as a sort of sacred scarecrow to frighten the devil away, preserving those inside in safety. Or perhaps gargoyles were themselves symbols of the evil forces—such as temptations and sins—lurking outside the sanctuary of the church; upon passing the gargoyles, the visitor's safety was assured within the church.

These interpretations, which make a distinction between outside and inside the church, have been refuted on the grounds that grotesque creatures appear within the church, too, although they are fewer in number and usually smaller in scale. A possible explanation for why there are, in fact, more monstrosities on the outside of medieval churches, especially in the form of gargoyles, than inside is that some of the evil monstrosities, having redeemed themselves by

laboring in the service of the church as waterspouts, were rewarded by being permitted entry to the church.

The English architect and architectural historian Francis Bligh Bond suggested that some gargoyles may have been symbolic, "the idea being that the Church overcomes and converts to good uses even the most monstrous forms of evil."[8] Gargoyles, frequently of no known species, may have been symbols of the unpredictability and chaos of life; the structure of the medieval church offered a way to deal with this disorder and danger. It has also been suggested that some gargoyles may represent souls condemned for their sins and therefore forbidden from entering the church. Although intercepted on their way to hell and spared from eternal damnation, they nevertheless have been turned to stone as the price for sinning. Some gargoyles, especially those in prominent locations, may have served as moralistic

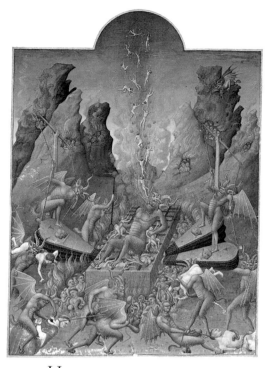

15. Hell, *from the manuscript* Les Très Riches Heures du duc de Berry, *1413–16, Ms. 65/1284, fol. 108 recto. Illuminated by the Limbourg brothers for Jean, duke of Berry. Musée Condé, Chantilly, France.*

reminders of what could happen to sinners. A gargoyle said to depict the devil devouring an unbaptized child on the south transept on the Church of Saint Aldhelm, in Doulting, England, supports this interpretation.

That certain gargoyles were intended to intimidate is made clear by the fearful reactions of the realistically rendered people (shown wearing clothing from c. 1500) who straddle the flying buttresses at the Cathedral of Saint John in Den Bosch, the Netherlands (plate 16). As a monstrous creature leaps out from the top of the buttress, the people cringe in terror, each one leaning back in an attempt to escape the attack of their horrible assailant. Similar encounters between different types of gargoyles and people are enacted on many of the cathedral's flying buttresses. This graphic depiction of the relationship between gargoyles and their intended victims is unique to the Cathedral of Saint John.

ABOVE: *16. Gargoyle threatening people, flying buttress, Cathedral of Saint John (Sint-Janskathedraal), Den Bosch, the Netherlands.*

OPPOSITE: *17. Group of gargoyles on balcony, southwest corner, Cathedral of Notre-Dame, Amiens, France.*

The devil was said to be always watching, much as gargoyles are always looking down on passersby. For example, at Amiens Cathedral in France a band of gargoyles on the balcony seem to be studying the visitors below (plate 17). Everywhere one looks, these silent observers are patiently watching. When the visitor to the Sainte-Chapelle in Paris or Rouen Cathedral in France looks up, looking down are gargoyles (plates 18 and 19). No matter where one goes, one falls under the gaze of yet another gargoyle. No person is alone, and no activity escapes notice. At the Cathedral of Saint John in Den Bosch or the Cathedral of Saint Rumbald in Mechelen, Belgium (plates 21 and 65), dour, if not disapproving, glares from the gargoyles are likely to make even the most pious visitor uncomfortable.

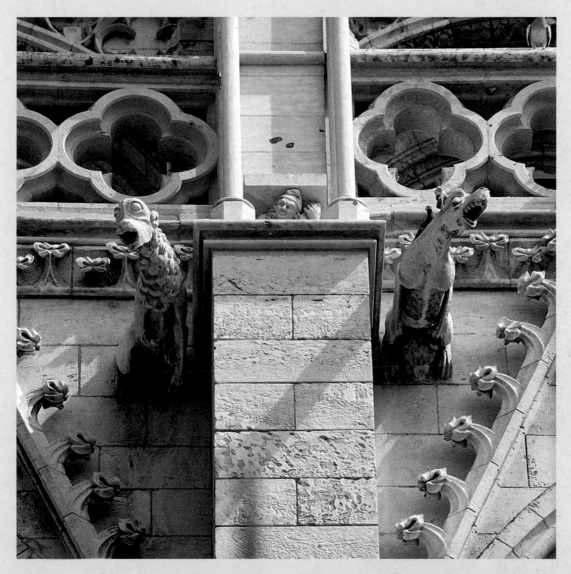

OPPOSITE: *18.* Gargoyles
on buttress, north side,
Sainte-Chapelle, Paris.

19. Gargoyles flanking
buttress, south side, Cathedral of
Notre-Dame, Rouen, France.

The interpretation of gargoyles as demons may explain why so many are perched high on the church, as if they had momentarily alighted or were frozen in flight, such as those on Beverley Minster in England (plate 20). An especially effective image of attacking monsters is seen in the *Temptation of Saint Anthony* by the German printmaker Martin Schongauer (plate 23). Anthony struggled with temptations, which he referred to as his "demons." This scene would be more accurately described as the torment of Saint Anthony, for with an evident delight in the demonic and an impressive display of inventiveness, Schongauer depicted Anthony surrounded by nine different monsters that brutally pull on the saint and hit him with sticks. Anthony's torment takes place in midair—the reputed realm of demons, as noted in Ephesians 2:2. Saint Bonaventura (1221–1274) described demons as a great swarm of flies; they were said to be so numerous that if a needle were dropped from above, it would surely strike one.

Perhaps so many ugly gargoyles were permitted on the church precisely because their repulsive physiognomies linked them to the devil and his demons. That such ugliness could have had a legitimate place on the medieval church, otherwise embellished with beautiful art, is explained by the notion that the devil is actually on God's side, doing God's work when he punishes the wicked. Countering this interpretation

20. Gargoyles atop Minster,
Beverley, England.

LEFT: 21. Gargoyles on corner buttress, Cathedral of Saint
John (Sint-Janskathedraal), Den Bosch, the Netherlands.

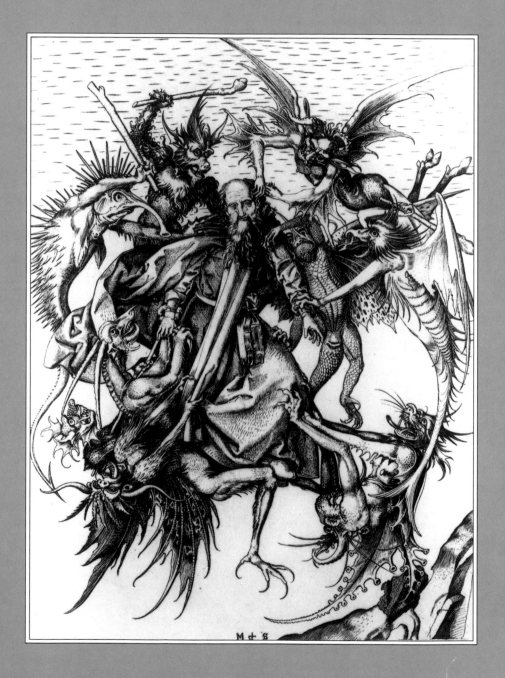

is the argument that if they were symbols of the devil in the service of God, Bernard of Clairvaux would not have objected to the same imagery when carved on cloister capitals. Yet, Bernard strongly criticized monstrous animals as diversions from religious concerns.[9]

Not all gargoyles were intended to frighten, reprimand, or threaten; some appear to have been intended to serve purposes not sacred but profane. Rather than inspiring dread, perhaps they were intended to amuse. Gargoyles may have been regarded as a form of popular entertainment long before the monsters created by Steven Spielberg and Stephen King captivated today's public. A significant number of gargoyles, even when they leer and sneer, have something appealing about them. For example, a charming and truly hybrid monster on Lichfield Cathedral in England (plate 22), with feathers, scales, and fur, takes the traditional pose of the usually human mouth-puller, as seen in plate 40. A winged doglike

22. *Winged composite creature, south side, Cathedral, Lichfield, England.*

OPPOSITE: 23. *Martin Schongauer (German, c. 1450–1491). Temptation of Saint Anthony, c. 1480–90. Engraving. Musée du Petit Palais, Paris.*

gargoyle crouching on what is now the National Bank of Belgium in Leuven appears to be having a hearty laugh at all the town's activities, observed from his high vantage point (plate 24). His sense of humor seems to be shared by a gargoyle with an overbite on the Cathedral of Saint John in Den Bosch (plate 25).

Carved with assurance, these lively creatures, their faces expressive and their poses animated, convey a remarkable sense of energy. Evidently equally amused (and amusing) are gargoyles such as one on the Town Hall of Bruges (plate 27), which has character—and gives character to the building. Sculptors of gargoyles such as a creature that appears to clutch the cove molding in the cloister of Hereford Cathedral in England (plate 26) deserve praise for their ability to cleverly combine architectural function with a seemingly endless variety of physical forms and expressions.

It is likely that what amuses us today about the

OPPOSITE:
24. Winged dog,
National Bank of Belgium,
Leuven, Belgium.

25. Laughing large-eared
monster, Cathedral of Saint John
(Sint-Janskathedraal),
Den Bosch, the Netherlands.

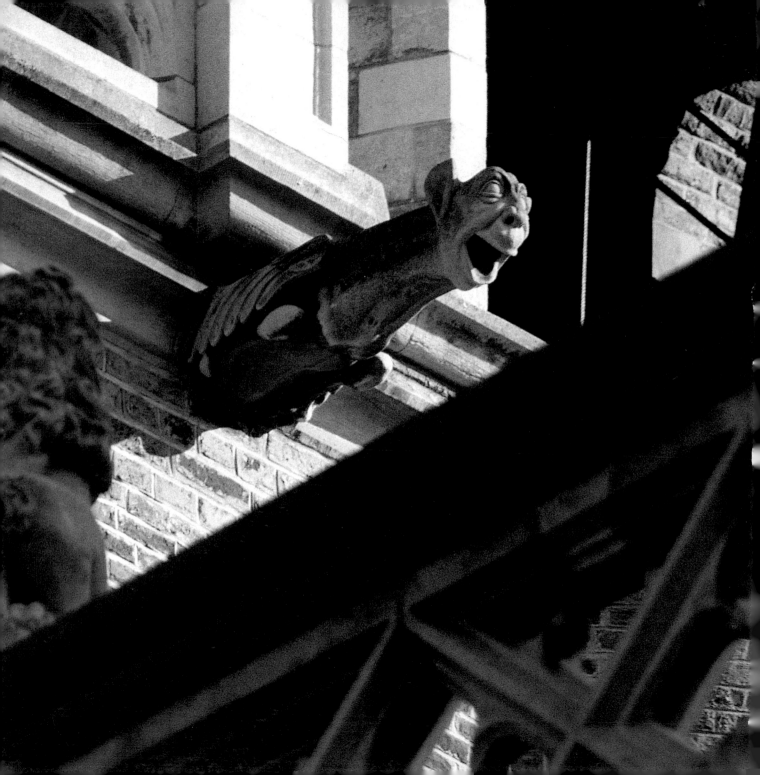

gargoyles also amused the people of the Middle Ages. For example, the gargoyles clustered around the yard of the cloister beside the Old Cathedral of Saint-Etienne in Toul, France, are placed quite low, permitting one gargoyle carved in the form of a monk holding a barrel on his shoulder to quietly empty its contents onto his unsuspecting colleagues below.[10] But even gargoyles such as this may well have conveyed more than pure fun to their creators and original viewers, for humorous imagery can be used to say things that otherwise could not be said, and satire has long been used to confront unpleasant, controversial, or frightening issues.

In another cloister, that of Oviedo Cathedral in Spain, a gargoyle abbreviated to only a head also amuses, for he truly seems to come to life, smiling broadly as he pops out at the unsuspecting visitor (plate 28). Is the meaning of such a creature the same in the cloister as on a secular structure? Consider the antics of an animated

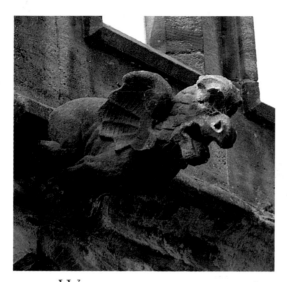

26. *Winged composite creature, cloister beside Cathedral, Hereford, England.*

OPPOSITE: 27. *Laughing winged monster, Town Hall (Stadhuis), Bruges, Belgium.*

little animal in the courtyard of the fifteenth-century Shell House in Salamanca, Spain, whose grin seems to repeat the pattern above (plate 29). Does he mock those who pass by? Or is his a friendly smile of greeting? And on a balcony in the courtyard of the Hôtel de Sens in Paris, built 1475–1507, originally as a home for the archbishops of Sens, an enthusiastic mouth-pulling imp may be a distant descendant of the mouth-pullers common in medieval churches. But, removed from the church, this little gargoyle seems to ridicule everyone who visits this elegant residence (plate 30).

In the unlikely event that such entertaining gargoyles were meant to represent the devil, it should be noted that although the medieval devil could terrify, he could also be droll. The devil may be made funny in a repulsive way; the comic and the disgusting often combine. In medieval folklore the devil gradually became less frightening, tamer, even a sort of buffoon.

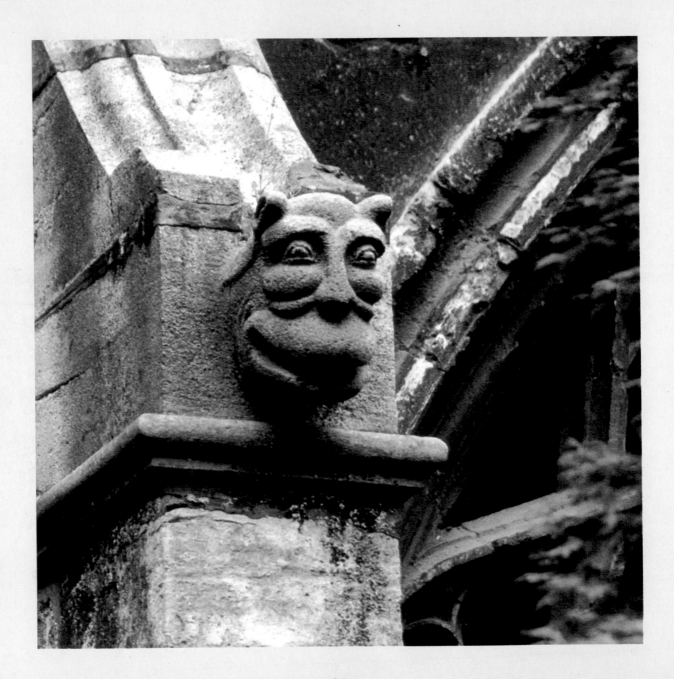

Although gargoyles have been described by Michael Camille as "all body and no soul—a pure projector of filth,"[11] some are so appealing that it is hard to imagine they were intended to be regarded as anything other than good creatures. Indeed, the gargoyles of Notre-Dame in Paris are even said to keep watch for drowning victims in the Seine.

Both points of view—gargoyles as good and bad—are served by a description found in the *Roman d'Abladane* (now known only in later copies), perhaps written by Richard de Fournival, a thirteenth-century bishop of Amiens and author of the celebrated *Bestiaire d'amour*. The *Roman d'Abladane* explains that master Flocars had made two "gargoules" of copper, on the gateway of Amiens, which were said to be able to evaluate the motivation of each person who came into the city. On anyone entering the city with bad intentions, the gargoyles would spit a venom so horrible that a person covered with it died. But when the lord of the city came, one of the gargoyles threw down gold and the other, silver.[12]

Gargoyles that are located so high as to be barely visible from the ground, however, could not have amused, frightened, or lured people to church. Nor are such gargoyles the only type of medieval art difficult to see because of high locations. Stained-glass windows, which, like the gargoyles, reached their peak of popu-

28. *Funny face, cloister beside Cathedral, Oviedo, Spain.*

larity in the Gothic era, often rise so high above the viewer's head that they are readable only as patterns of colored light. Yet at the French cathedrals of Chartres and Bourges, at the Sainte-Chapelle in Paris, and elsewhere, the scenes at the tops of the windows are as carefully made and as finely detailed as those at the bottoms.

Why create art on public buildings that can barely be seen by the public? Perhaps the answer is that this art was not intended solely for the earthbound human. Instead, the highest gargoyles and windows may have been made for God. A basic biblical concept holds that God is above the earth, looking down from the highest heavens. The Old Testament describes a three-tier universe with God and heaven above, the living people on earth in the middle, and hell below. Because God was believed to be on high, the medieval church or cathedral was routinely built on the most elevated land in town. These buildings were made as gifts to God and were dedicated to God rather than to their congregations or physical creators. When building these monuments for the glorification of God, there could be no skimping anywhere; nothing was considered too rich, no task too difficult, to praise God. Because God was believed to be everywhere, all parts of the church were likely to be made to the same level of perfection, including gargoyles and

stained-glass windows, even when located in places not easily seen.

Due to the religious role of much of medieval art, open expression of personal artistic style was not characteristic. A medieval artist was regarded as no more than an artisan, working anonymously within the guild system. Careful craftsmanship was desired; deviation from standard representation was not. An artist was told what to depict and how it was to be depicted. Artists would routinely copy the work of their predecessors—without the negative connotation of plagiarism—and the use of model books was customary. The modern belief that artistic innovation is innately desirable was unfamiliar to medieval artists.

Much of the art commissioned by the Church (the major source of patronage during the Middle Ages) was created within strict guidelines because it was intended to decorate and educate simultaneously by illustrating Christian religious teachings. However, there were few restrictions on the gargoyle sculptor's artistic license. Carving creatures that were to be placed out-of-doors in ancillary areas of the church, sculptors of gargoyles seem not to have been bound by the usual restraints imposed on more prominently placed sculptures.[13]

The tiny monstrosities that populate the margins of medieval manuscripts deserve comparison to the

29. Amusing monster, courtyard, Shell House, Salamanca, Spain.

gargoyles, for their behavior, too, was rarely more refined than their physiognomies.[14] The manuscript illuminator worked with pen or brush in the margins of the folios; the sculptor did the same with chisel and mallet in the margins of the church. Once outside the confines of the church, literally and figuratively, illuminator and sculptor seem to have been freed from the normally restrictive rules.

Like gargoyles and manuscript marginalia, medieval misericords, most of which were made in the fourteenth and fifteenth centuries and thus coincide chronologically with many gargoyles, were a breeding ground for fantastic animal imagery. A misericord is a "mercy seat," a small ledge supported by a carved corbel (a type of bracket) on the underside of a choir stall seat; when tipped up, it provides a place for the clergyman to support some of his weight while still appearing to stand. When not in use, the misericord is tipped down and out of sight underneath the seat. Curiously, although misericords were intended solely for use by the clergy, they were carved less often with sacred subjects than with scenes from mythology, folk tales, and daily life and especially with animals—common, exotic, and fabulous. Some record behavior that can only be described as crude.[15] Perhaps this is because the purpose of the misericord is a humble one. And perhaps the same is true of the

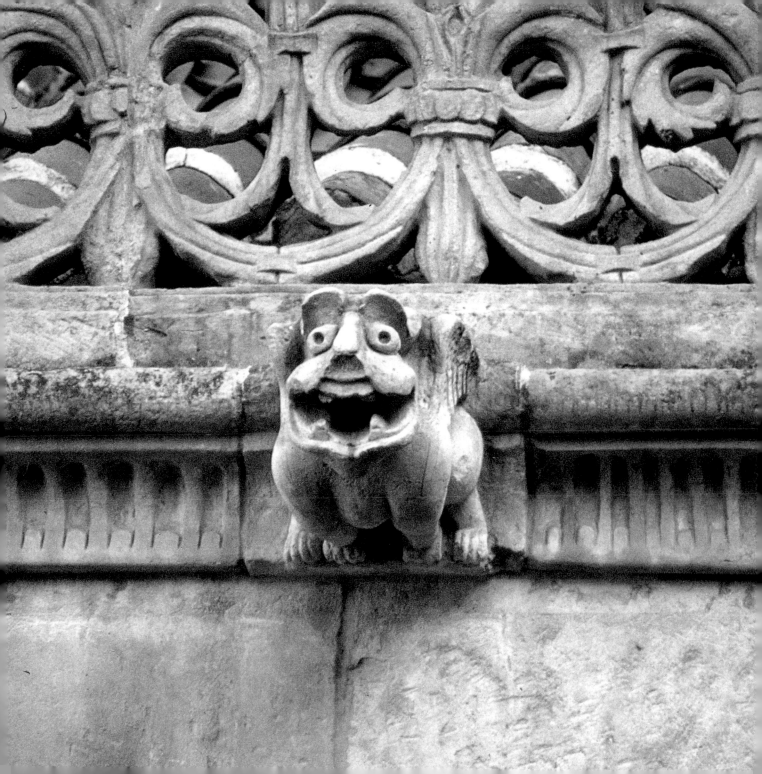

gargoyles, which also are mundane structural necessities that have been enlivened by carving. Yet the totality of the church, from the gargoyles along the roofline to the misericords beneath the seats, is within the view of God and was made for God. This purpose transcended the necessity of removing water from the roof or giving rest to weary monks.

The seemingly eccentric aspects of the gargoyles and misericords, as well as of carvings on corbels, vault bosses, and other locations at a distance from the focal points of the medieval church, may be the result of the diminished restraints placed on the sculptors when working on these parts of the church. There carvings could have been made more for the satisfaction of the artist and fellow workers. Ego is not a modern invention. The individuality of the gargoyles may have been a way of making something personal in an era when it was not customary for artists, no matter what medium they worked in, to distinguish the images they made from those by their fellow artisans. The highest and most obscurely located gargoyles offered sculptors a rare opportunity to create something profoundly personal within the anonymity of the guild system.

Gargoyles continue to be carved today. Perhaps the most notable are at Oxford University, where the seemingly countless gargoyles and grotesques are constantly being restored and renewed. Oxford's oldest extant colleges date back to the thirteenth and fourteenth centuries and were originally founded for the education of the clergy; thus, the gargoyles should feel comfortable there. Some new sculptures replacing those that have been damaged or destroyed are "interpretations" of medieval gargoyles, others are thoroughly modern in style and meaning. For example, the sculptures now include a caricature of the sculptor-mason Percy Quick. Today's carvings tend to be more comic, less demonic than those of the Middle Ages.

America's closest equivalent to Oxford University's gargoyles is offered by carvings on several of the buildings of Princeton University, in New Jersey. Although not necessarily functional gargoyles, these modern examples reveal a debt to their medieval ancestors in their wit. One monkey takes a picture with a camera, another is dressed as a clown, and yet another reads a book. Guyot Hall (built in 1909 by Parrish and Schroeder), appropriately, has portrayals of living animal species on the wing devoted to biology and of extinct animals on the wing devoted to geology. Some of these may have been made in the studio of Gutzon Borglum, sculptor of Mount Rushmore.

Many secular nonscholastic buildings in America also appear to be gargoyled; the forms have been perpetuated but not their function as gutters. The Chrysler Building in New York City (completed in

1930), celebrated for its soaring height and slender spire, seems to be the twentieth-century architect's equivalent of the Gothic cathedral mason's quest for ever higher ceilings and towers. Accordingly, the Chrysler Building has its gargoyle-like ornaments, high above, in the form of geometricized eagles, as angular and modern in style as their skyscraper perch; unlike their medieval ancestors, they are all identical rather than individualized.

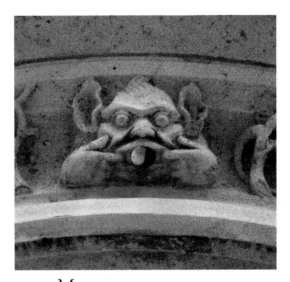

30. Mouth-puller imp, on balcony in courtyard, Hôtel de Sens, Paris.

rizes Morigi's quick temper, for he is shown holding onto his hat while "blowing his top." Work done at Washington Cathedral in the early 1980s by the Chicago-based sculptor Walter S. Arnold includes a gargoyle in the form of a crooked politician (carved of Indiana limestone, weighing about 500 pounds). Washington Cathedral has functioning gargoyles, equipped with metal pipes that project only slightly and are barely noticeable.

For gargoyles on religious architecture in America, two places are especially recommended: the Cathedral Church of Saint Peter and Saint Paul in Washington, D.C., and the Cathedral Church of Saint John the Divine in New York City. Washington Cathedral (begun in 1907) has 106 gargoyles. A donation of $1,800 makes it possible to commission a personal gargoyle; a dentist, for example, commissioned one in the form of a dentist polishing a walrus tusk. The master carver, Roger Morigi, is the subject of a gargoyle designed by one of his colleagues that satirizes

At Saint John the Divine (begun in 1892 and still largely unfinished) carving continues today under the supervision of the master sculptor, Simon Verity. The Cathedral Stoneworks, responsible for the sculpture, works with rockwood imperial shadow-vein limestone quarried in Alabama. Six sculptors recently were hired to carve interpretations of medieval gargoyles. These are referred to as gargoyles, but modern building construction and materials have largely relegated gutters, and therefore gargoyles, to the past. Although positioned as if they were functioning gargoyles and carved in forms quite faithful to those of

the Middle Ages, the mouths of these gargoyle imitators are closed. When the term *gargoyle* is used today, it is usually in reference to sculptures of creatures that are physically monstrous but incapable of spouting water; they are more correctly called *grotesques*.

What makes gargoyles so fascinating that they are still carved today, even though no longer serving an architectural function?[16] In part, it is the imaginative freedom unleashed by a subject with so few limitations. Even after so many years have elapsed, gargoyles carved during the Middle Ages still convey a sense of irrepressible life. Their immediacy and their animation make gargoyles look ready to use their stone wings to take flight when the shadows darken.

The ongoing history of gargoyles is linked to the fact that the macabre continues to exert a powerful magnetism. We humans seem to be attracted to the monstrous, lured by the lurid, especially by images of the unknown and the unknowable, by beings that the mind believes (or hopes!) do not exist. The sculptors of gargoyles made permanent images of the inhabitants of our nightmares; the imagined horrors that one assumes will vanish upon waking have been carved in stone.

Today's affection for the grotesque is especially evident in the current popularity of horror films. Curiously, what frightens us seems to have changed in recent years. The mere idea of the vampire Dracula sucking his victim's blood once incited terror, yet today Dracula movies have become "cult classics"— a term implying a degree of affection. Today's villains —and even heroes—are more likely to be grotesquely transformed from human shapes, recalling the monstrosities of the Middle Ages. The public's ghoulish tastes for ever more gore make destruction, suffering, maiming, and mutilation all box-office attractions. Today we go out of our way, and are willing to wait in line and pay, to be frightened. Viewers confront the disfigured Freddy Krueger wearing a glove with metal talons in *Nightmare on Elm Street*. Actors on the long-running television series "Star Trek" portray the Borgs, a race of cyborgs who transform others into members of their evil race. Cartoon animators create the children's program "Gargoyles," in which the evil Demona is magically changed from a beautiful woman into a monstrous gargoyle. The computer game Doom pits the player against demons depicted as red humans with blood dripping from their mouths. The inventors of these and other modern media monsters seem to compete to create increasingly graphic forms of fright—and to induce the accompanying adrenaline rush.

Perhaps the fascination with the grotesque continues unabated because of its appeal to deep-rooted needs in human nature. Gargoyles and other creatures embody images from our subconscious—part of our

inner personality given visual form. The enduring appeal of these images may lie in the curious fact that they can be simultaneously repulsive and attractive. The monstrous, the novel, even the nasty—things that intend to offend—have an odd allure. Perhaps today's indulgence in horror is a reflection of the anxieties of society. Or is it a form of escape from those anxieties? The modern horror movie, like the medieval gargoyle, pretends to threaten us but does no harm.

Gargoyles constitute a particularly intriguing—and puzzling—application of the art of sculpture. Although having long exerted their attraction, they have received very little art-historical attention, and they are absent from all major studies on medieval sculpture. The delay in photographing and studying gargoyles is particularly regrettable because of their ongoing deterioration. Yet only in relatively recent times have the examination and documentation of gargoyles been made possible by the development of telephoto lenses of an affordable price and of a weight suitable for use by the traveling photographer and historian. Today, a powerful telephoto lens permits access to a world to which the modern viewer was never intended to be invited.[17]

HUMAN GARGOYLES

Only occasionally were gargoyles carved in the form of realistically represented humans. Although depictions of angels, Christ, Mary, saints, and other religious personages abound in medieval sculpture, they do not seem to have been popular as gargoyles. Firm evidence that specific secular individuals were portrayed is rare. The gargoyle knights wearing armor of mail that appear on the base of the tower of the Münster of Freiburg, Germany (begun c. 1200), represent the counts of Zähringen— founders of the city of Freiburg in the eleventh century. An unusual example of a gargoyle that represents a specific person contemporary with the building on which it is located is that of Ralph Boteler, the impressively mustached lord of Sudley Manor, on the Parish Church of Saint Peter in Winchcombe, England. This church is noted for its forty gargoyles, of which about half may be

31. Head of man, west facade, Cathedral, Salisbury, England.

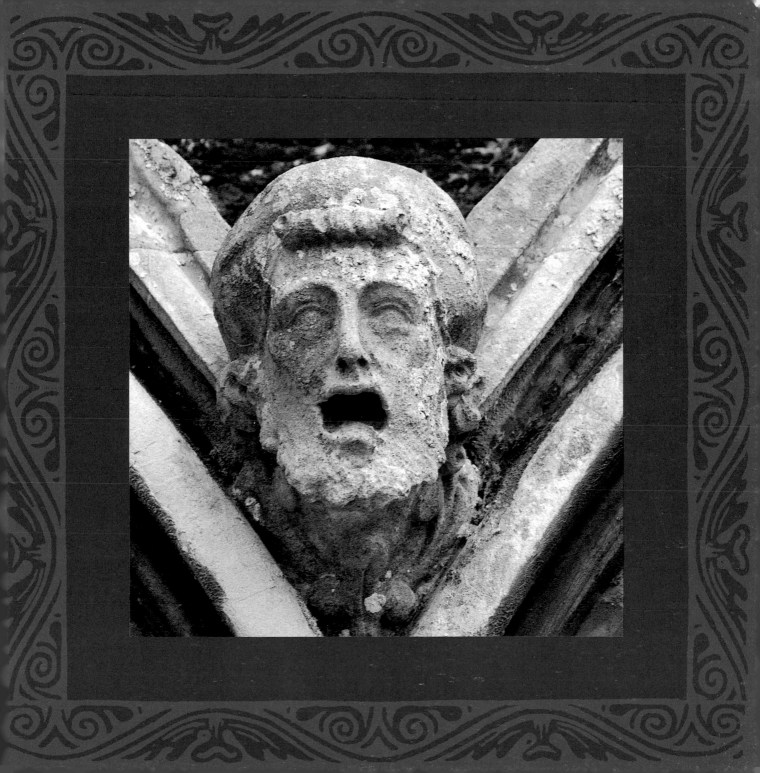

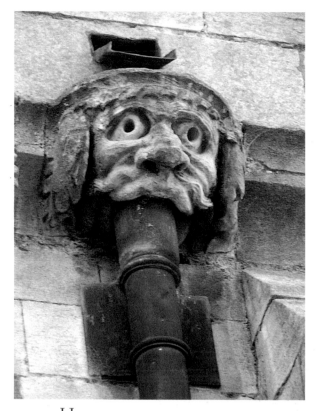

32. *Head of man, Parish Church of Saint Wulfram, Grantham, England.*

33. *Child, west facade, right portal, Cathedral of Saint-Pierre et Saint-Paul, Troyes, France.*

fifteenth-century caricatures of local people, while the others represent demons. Is a connection to be inferred?

Although not as numerous as animal gargoyles, human gargoyles do come in a wide range of types. Only a head may be shown—be it handsome, as on Salisbury Cathedral in England (plate 31), or comic, as on the Parish Church of Saint Wulfram in Grantham, England (plate 32). When the entire body is depicted, it may be quite beautiful, like the graceful child on the Cathedral of Saint-Pierre et Saint-Paul in Troyes, France (plate 33), or bizarre, like the enthusiastic imp-man on the Church of Saint John the Evangelist in Elkstone, England (plate 34).

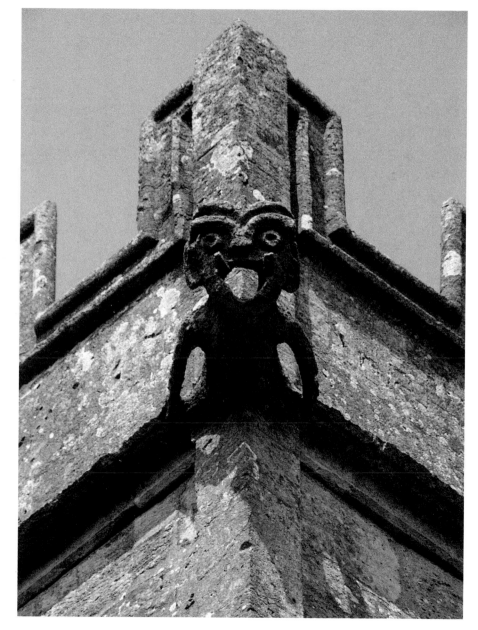

34. *Imp-man, corner of tower, Church of Saint John the Evangelist, Elkstone, England.*

Human gargoyles are more often bizarre than beautiful in their anatomy and more often laughable than laudable in their behavior. Some engage in activities that are surprisingly bawdy, given their location on churches and cathedrals, while others go far beyond the bounds of conventional decency. A modern misconception holds the Middle Ages to have been an extremely serious era in which fun was assiduously avoided. In fact, built into the Church calendar were events such as the Feast of Fools—starting January 1 and lasting several days each year—during which the social hierarchy was inverted, an example of the *inversus mundi* (world turned upside down), a concept also found in other contexts during the Middle Ages. (The medieval Feast of Fools may have been a Christian perpetuation of the ancient pagan Roman Saturnalia, a midwinter indulgence in license, games, and revelry.) The populace elected its own religious leaders and luxuriated in impiety and obscenity, singing, dancing, and masquerading. This event took place *within* the Church; the Feast of Fools was not a display of contempt for the Church. In fact, the Church may cleverly have reinforced its authority by keeping satirization under its control. A similar sense of fun (and crudeness) is embodied in gargoyles.

Certain people depicted on corbels and as gargoyles, the "margins"

of the church, may represent those considered marginal to medieval society and condemned by law and Church, banished from towns, or institutionalized: drunkards (like the man holding a pitcher and cup, with a fool's head below, on the Church of Notre-Dame in L'Epine, France), vagabonds, dice players, jugglers, and so on. People who were sick or afflicted with physical abnormalities (thought to reflect mental ones), as well as the mentally retarded, might also be depicted.[1] Other gargoyles may satirize those engaged in businesses frowned on by the Church, such as prostitutes and moneylenders, or to mock human foibles and vices. The immobile stone gargoyles, with their frequently pained expressions as they perform their simple job of water spouting, were compared by the English preacher John Bromyard to slothful clergy "who complain of the least task."[2] A French expression describes a lazy person as having hair growing on the palms of his hands; some gargoyles, such as one on Burgos Cathedral in Spain (plate 35), have more than hairy palms. It has been suggested that supporting figures that function as corbels represent people punished by being made to hold up the church.[3] Gargoyles, which are also functional portions of the architecture, similarly may have been symbols of sinners punished by having to perform menial plumbing tasks.[4]

35. Hairy human with animal head, Cathedral, Burgos, Spain.

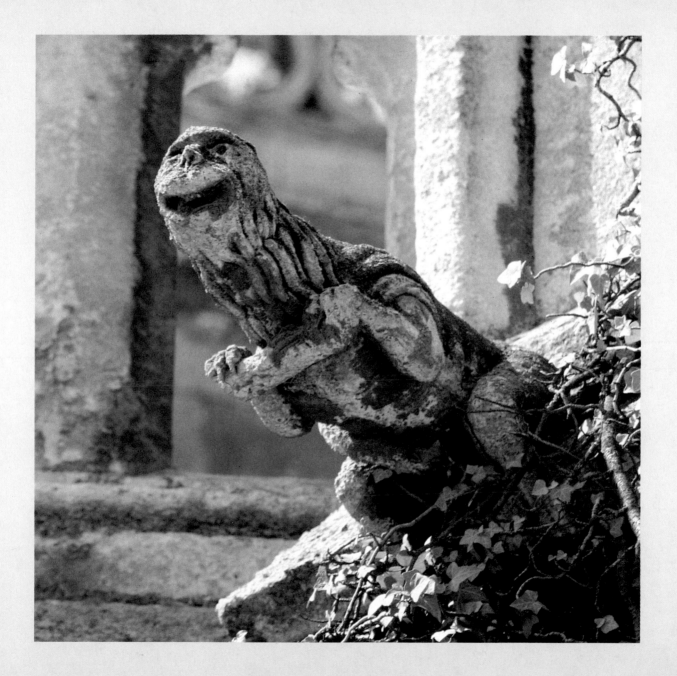

The imperfect physical characteristics of many "human" gargoyles are probably connected with the medieval belief that physical ugliness, oddity, and illness were caused by demons and associated with evil, whereas physical beauty was believed to be a reflection of inner goodness. Thus, in medieval art Christ is always handsome and Mary beautiful, whereas Christ's assailants are shown to be monstrously ugly. Overt displays of emotion, evidenced by many gargoyles, carried similar connotations of diminished worth or status. For example, the most demonstrative characters in the art of the

OPPOSITE: 36. Man with hands on head, Minster (Cathedral Church of Saint Peter), York, England.

twelfth and thirteenth centuries are the condemned sinners bewailing their torment in hell. Extreme expressions of grief in Crucifixion scenes were usually reserved for Mary Magdalene, the reformed sinner, whereas those of higher status were shown to mourn with restraint.

The emotions conveyed through gargoyles' gestures and facial expressions are impressively varied and extremely vivid. At York Minster in England a gargoyle howls, hands on head (plate 36). The expressions of such gargoyles may not have been intended to produce an emotional response in the viewer. Instead, the gargoyles' display of emotion may be in response to what they observe, which means their expressions should be interpreted not as frightening but as frightened. Do gargoyles that crane their necks to glance toward their neighbors react to one another in fear? Or do wailing gargoyles, such as a hooded man who seems to use his pipe to amplify his voice

37. Hooded man, Parish Church, Thaxted, England.

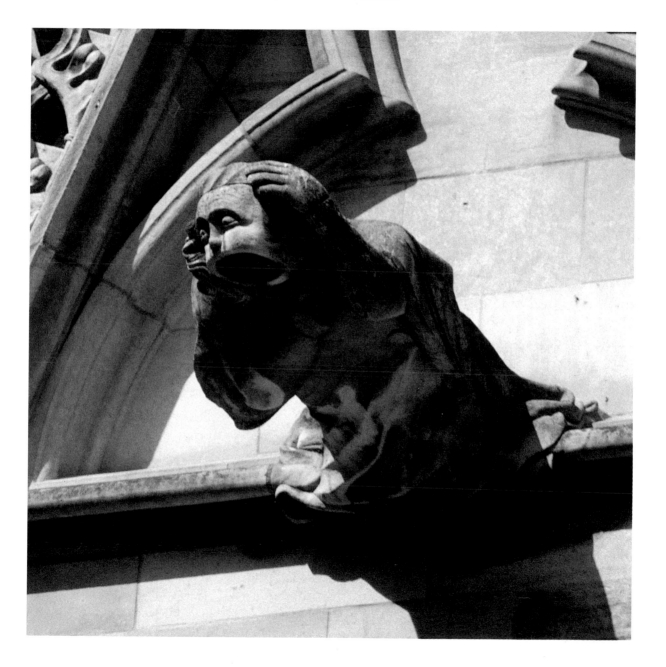

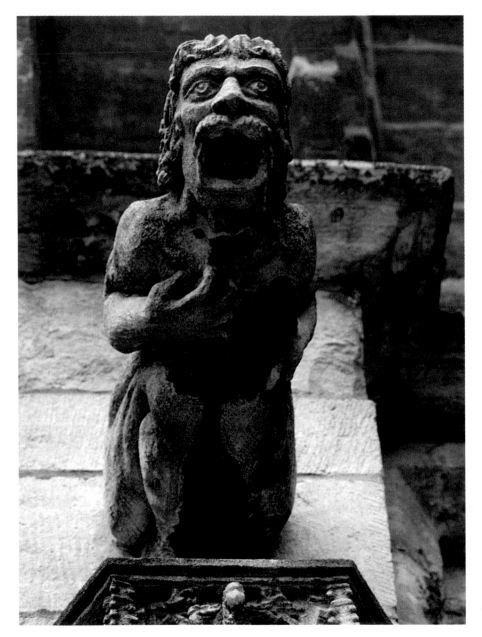

38. Crooning man, Town Hall
(Hôtel de Ville), Brussels.

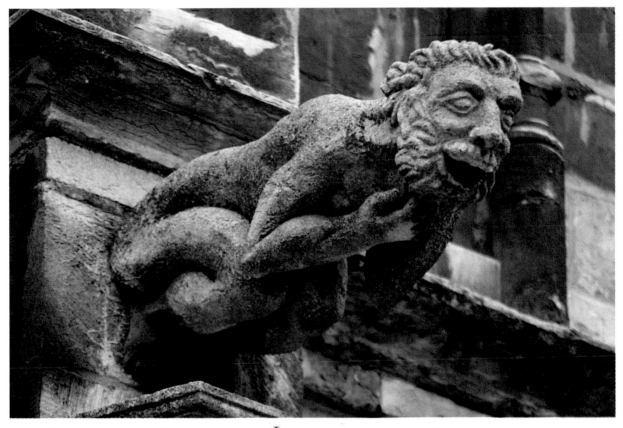

39. *Laughing man, Town Hall (Hôtel de Ville), Brussels.*

at the Parish Church of Thaxted in England (plate 37), bemoan the evil habits of the people they see below? A gargoyle, partially clothed, in the cloister beside the Old Cathedral of Utrecht in the Netherlands, dispenses his water with gusto—or with disgust—on the passersby (plate 62). The degree of animation seen here is characteristic of gargoyles as a whole; rarely is a gargoyle's expression bland or subtle.

Although the open mouth required for the issue of water often looks like a cry, this is not always the case. At the Town Hall in Brussels, a gargoyle appears almost to croon to the visitor below (plate 38), while his friend seems to laugh (plate 39). These gargoyles also seem to interact with one another and with the people passing by below.

Other gargoyles use their hands to pull their

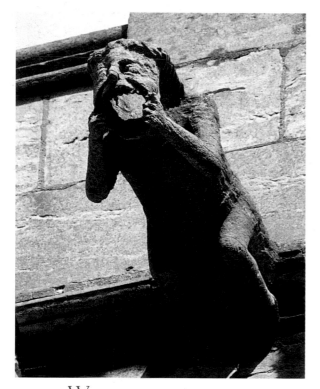

40. *Well-dressed mouth-puller, Parish Church of Saint Wulfram, England.*

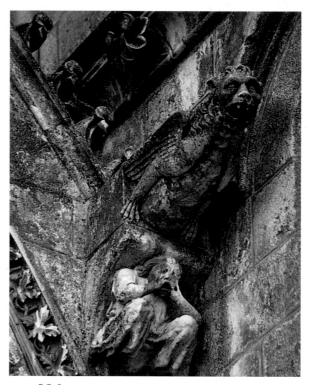

41. *Winged lion with crouching mouth-puller, west facade, Cathedral of Saint-Pierre, Poitiers, France.*

large mouths open even wider, as does the well-dressed man on the Parish Church of Saint Wulfram (plate 40). Mouth-pullers, human and bestial, appear with some frequency in medieval art, carved as gargoyles, on corbels, and elsewhere. The mouth pulled open suggests the face of a devouring giant and may refer to the sin of gluttony. Per-

OPPOSITE: 42. *Mouthpuller with crouching boy, Church of Notre-Dame-de-la-Chapelle, Brussels.*

haps face-pulling is linked to Christ's torment by those who spat in his face, struck him with the palms of their hands, or pulled his hair. However, the mouth-pulling gestures may be considerably more lighthearted; grimacing games are depicted on English choir stalls, and competitions in face-pulling had a long tradition in England, continuing

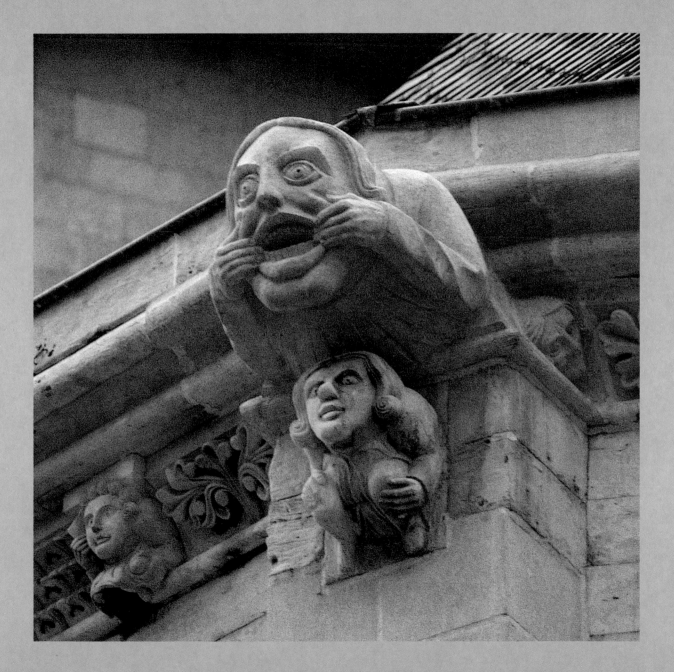

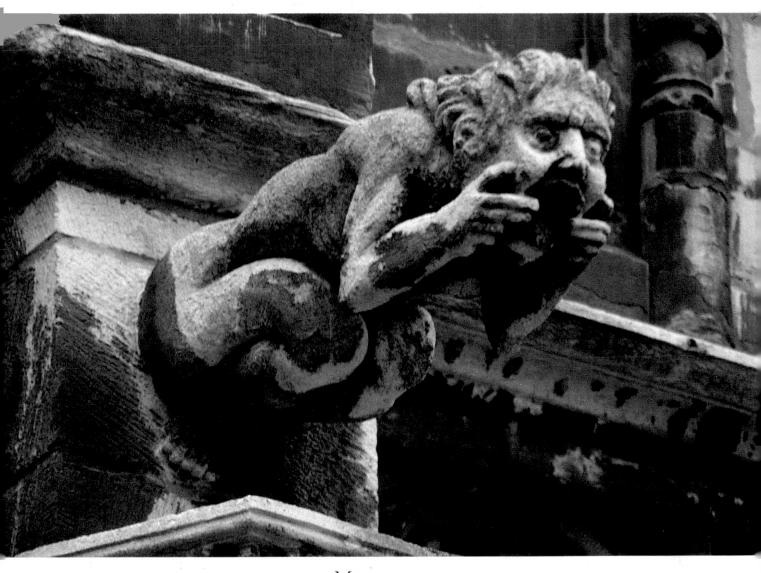

43. *Mouth-puller with tongue out, Town Hall (Hôtel de Ville), Brussels.*

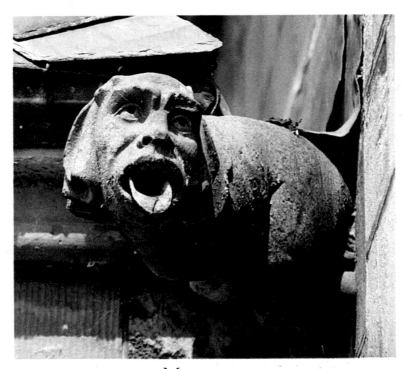

44. *Man with tongue out, Cathedral of Saint John (Sint-Janskathedraal), Den Bosch, the Netherlands.*

to recent times.[5] The popularity of the mouth-puller is demonstrated by examples on the Cathedral of Saint-Pierre in Poitiers, France (plate 41), and the Church of Notre-Dame-de-la-Chapelle in Brussels (plate 42). Both are complex gargoyles combining two figures, one atop another. In the Poitiers example, medieval in date, the mouth-puller crouches below a winged lion. In the Brussels example, of modern manufacture, the toothy mouth-puller overshadows a crouching boy.

Some gargoyles stick out their tongues through their open mouths, as does a naked man on the Town Hall in Brussels (plate 43). A rather rotund fellow on the Cathedral of Saint John in Den Bosch, the Netherlands, sticks out his tongue, facilitating the flow of water (plate 44). Medieval artists sometimes depicted Satan sticking out his tongue to mock his victims. The protruding tongue was also used to symbolize traitors, heretics, and blasphemers. Conversely, the gesture may be used to keep evil at bay.

Elsewhere there is a strong implication that

something other than rainwater spews forth from a gargoyle's mouth. Some gargoyles grasp their throats or chests as if vomiting, as on the facade of the Cathedral of Saint-Pierre in Poitiers (plates 45 and 46). The hand-to-throat gesture seen in plate 45 has also been described as the *signe à l'ordre du compagnon* ("sign of the order of the journeymen"), which consists of placing the right hand, with the thumb forming a right angle, on the throat.[6] There existed in France during the Middle Ages (and continuing even today) a society of artisans, "les compagnons du tour de France." A *compagnon* would make a tour around France, going from one master to another. One year later he was required to produce a chef d'oeuvre to demonstrate what he had learned; if the work was judged good enough, he became a master craftsman in his art. While making their tours, the *compagnons* learned trade secrets they were sworn not to divulge, with the consequence that only *compagnons* were able to do certain things and make certain designs in wood and stone—thereby "signing" their work as members of *l'ordre du compagnon*. The right-angle hand sign, which related to the right-angle tool or square, was used in rituals performed before a person was accepted as a *compagnon*, and this sign

of secrecy also preceded all discussions at the *compagnons'* lodge. The sign recalls as well the fact that Saint Blaise, one of the patron saints of masons, is also the protector of the throat. When employed by a gargoyle, this gesture evokes a connection with Saint Blaise and perhaps warns people to be attentive to the dangers that pass through the throat—whether food, drink, or words. But when Adam is shown with his hand on the "Adam's apple" in his throat, it is a reference to his souvenir of original sin and the Fall.

On occasion water exits through an orifice other than the mouth. An extraordinary gargoyle in the form of a defecating man appears on the Cathedral of Saint-Lazare in Autun, France (plate 47). Is he intended to drive evil from the church?[7] Or is this merely a bit of medieval mischief? Rather than being prominently positioned, he is tucked away, high on the south side of the cathedral, as far as possible from the center of town. Autun's excreting gargoyle is not unique; there are other examples in Germany, England, France, and possibly elsewhere. The Autun gargoyle, believed to date from the end of the thirteenth century, seems to have a descendant on the Münster of Freiburg, where a defecating gargoyle was carved in the fifteenth century

OPPOSITE, LEFT:
45. Man *with hand at throat, west facade, Cathedral of Saint-Pierre, Poitiers, France.*

OPPOSITE, RIGHT:
46. Horned man *with hand at chest, west facade, Cathedral of Saint-Pierre, Poitiers, France.*

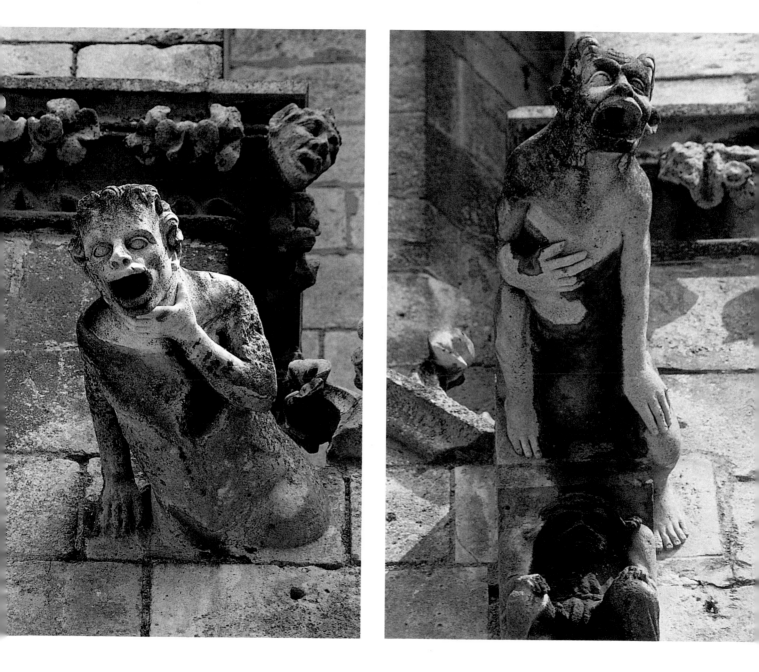

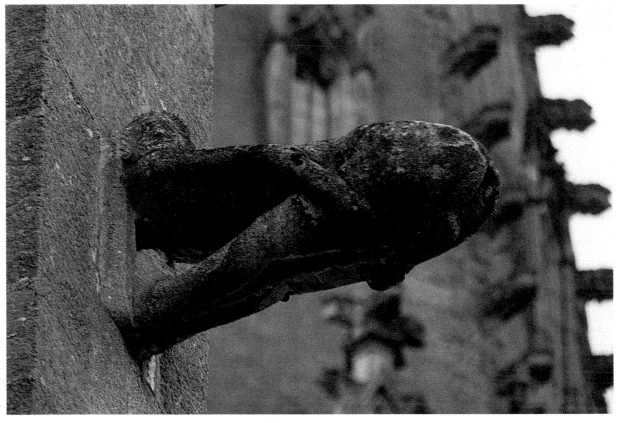

47. D*efecating man, south side, Cathedral of Saint-Lazare, Autun, France.*

(plate 48). On the Angel and Royal Hotel in Grantham, rebuilt in the mid-fourteenth century and again in the fifteenth century, is another defecating man. Unlike those at Autun and Freiburg, which are very clearly seen to be naked people, the one at Grantham is notable for being less noticeable. Perhaps out of respect for his exposed position on the facade, this gargoyle, when viewed from the front, appears to be nothing more than a large head with an open mouth from which water can issue. However, when observed from the right side, it becomes clear that this is a man and that the orifice is the opposite end of his alimentary tract. And in Paris, on the outer wall of the Musée National du Moyen Age (Thermes de Cluny), once the residence of the abbots of Cluny, is a gargoyle carved c. 1500 in

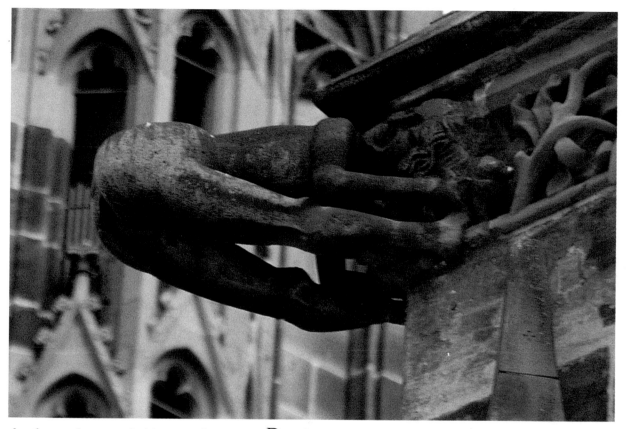

the form of a man holding on his shoulders another man who, with bared buttocks thrust out, appears to defecate.[8]

48. Defecating person, south side, Cathedral of Our Lady (Münster), Freiburg, Germany.

That many human gargoyles are nude or nearly nude is notable because the nude was rarely depicted in medieval art—only when required by a subject, such as Christ crucified. Anatomical accuracy was neither necessary nor likely; rather than studying directly from a live model, one artist learned by copying the work of another. Adam and Eve, naked in the Garden of Eden before the Fall, represent purity and innocence; thereafter, according to biblical tradition, nakedness is a symbol of shame and absence of virtue. The range of garments that might be worn by gargoyles is indicated by a realistically rendered older man, seemingly a tired worker, in a twentieth-century

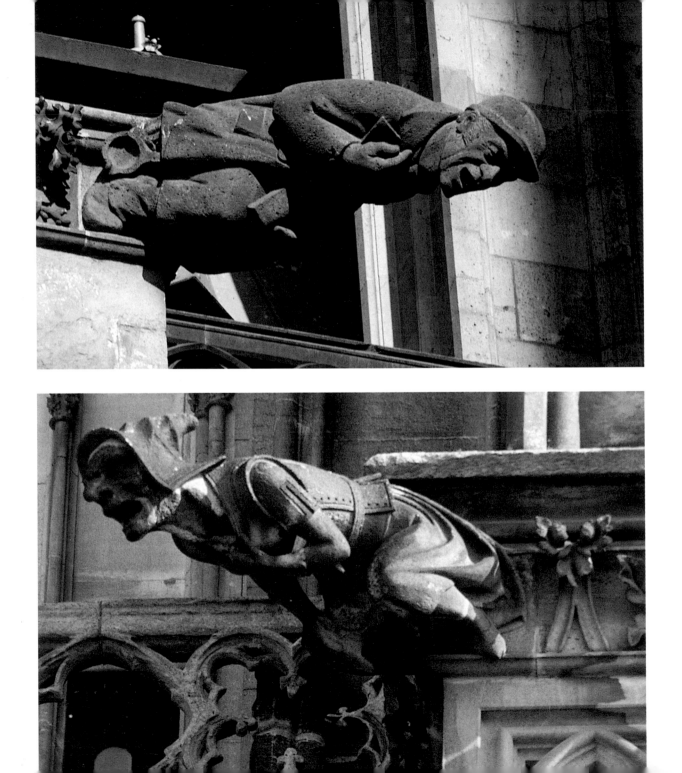

overcoat and cap (plate 49) and by a somewhat more caricatured man in fitted medieval-style armor and helmet (plate 50)—both on Cologne Cathedral.

It is curious that nude gargoyles are not shown to urinate, which would seem to be a natural function for them. Propriety obviously cannot be the explanation, nor was the Middle Ages without urinating sculptures. The male figures on the fountain known as the *foun das pissaires*, at Lacaune, France, made in 1399, are said to have been erected as a symbol of the diuretic qualities of the area's water.[9] The enduring popularity of the Manneken Pis fountain in Brussels (sculpted in 1619 by Jerome Duquesnoy the Elder) suggests that there was no later aversion to this subject that might have caused such figures to be removed. It seems most likely that urinating gargoyles did once exist but have not survived.

Human gargoyles that appear to drool, spit, vomit, or defecate from above when it rains may produce a sense of alarm in the person passing below, but it is likely to be followed quickly by one of amusement. Many gargoyles must have been as entertaining during a medieval rainstorm as they are today.

Sometimes the rainwater issues not from a bodily orifice but from an object held by the gargoyle. The Basilica of San Marco in Venice (plates 51 and 52) has a series of huge *doccioni* (rain-pipe holders) in the form of men, clothed or nude, whose shoulders support vessels from which water pours. These early fifteenth-century *doccioni* are attributed to Pietro Lamberti and Jacopo della Quercia. Similar to these are the *doccioni* or *giganti* on Milan Cathedral (plates 53 and 54), which also are huge and mostly male. Usually clothed, each one holds an animal on his shoulders; the water issues from the animal's mouth.

The *doccioni* and *giganti* are unusual forms of gargoyles in that they are full-length standing figures. Some of those on Milan Cathedral are mentioned in documents beginning in February 12, 1404, which identify specific sculptors by name, including Matteo de' Raverti, Jacopino da Tradate, and Nicolo da Venezia.[10] Such early documents rarely survive, and still less frequently are the sculptors of gargoyles from this period identified. The number of *giganti* on Milan Cathedral (many more traditional gargoyles appear higher up) may have to do with the fact that among the numerous architects of the cathedral were several from north of the Alps, where the Gothic style of architecture and its gargoyles flourished.

The Milan *giganti* belong to a subcategory of gargoyles that consists

OPPOSITE, TOP: **49.** Man *in twentieth-century clothing, Cathedral, Cologne, Germany.*

OPPOSITE, BOTTOM: **50.** Man *in medieval clothing, Cathedral, Cologne, Germany.*

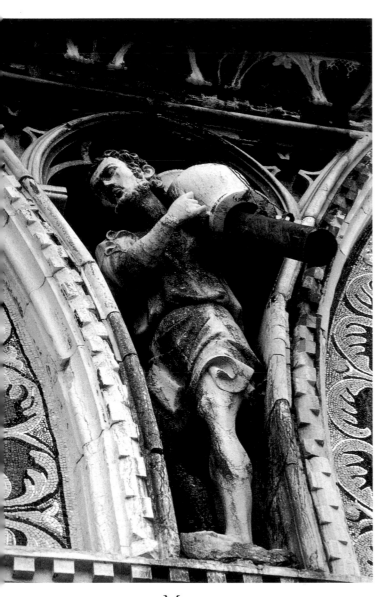

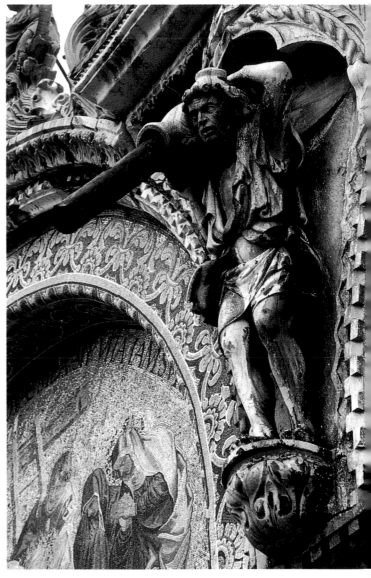

51. Man holding vase, west facade,
Basilica of San Marco, Venice.

52. Man holding vase, west facade,
Basilica of San Marco, Venice.

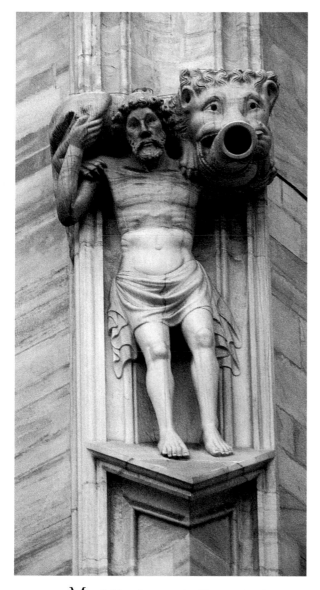

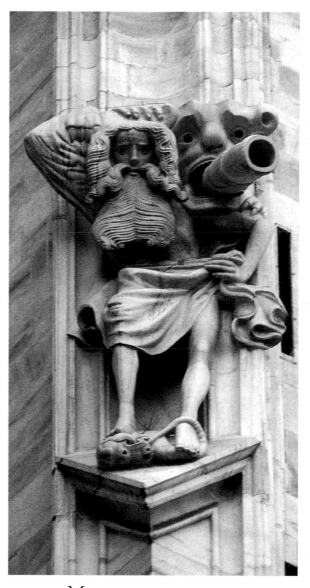

53. *Man holding lion over shoulders, south side,*
Cathedral of Santa Maria, Milan.

54. *Man holding worried monster, south side,*
Cathedral of Santa Maria, Milan.

of two figures—one a person, the other an animal. Some members of this subcategory relate to religious iconography—for example, a gargoyle that represents Jonah and the whale on the Church of Saint-Germain-l'Auxerrois in Paris.[11] Others, such as the nearly nude man with a lion across his shoulders (plate 53), might represent Hercules or Samson, but there is no sense of struggle on his bored face. Comparison with his companion (plate 54) seems to suggest a comic second act, for his beard is now long, and he labors under the weight of a worried creature that looks as if it clings to him.

Others are less well behaved. Consider the antics of a barelegged woman straddled by a goat, both of whom are smiling as they emerge from the shadows at the Church of Notre-Dame-des-Marais in Villefranche-sur-Saône, France (plate 55). During the Middle Ages the devil was sometimes shown as a goat, an animal associated with lust, lechery, and license. Similarly, on the apse end of the Cathedral of Saint Rumbald in Mechelen, Belgium, an extraordinary encounter is depicted between a nude woman and a monkey who grasps her from behind. Monkeys, long noted for their resemblance to humans, were also used to represent the devil or sinners in medieval art.

Neither the woman-and-goat nor the woman-and-monkey gargoyle is

55. Smiling woman and goat, north side, Church of Notre-Dame-des-Marais, Villefranche-sur-Saône, France.

in a prominent or even easily visible location. The former is obscured by shadows on the north side of the church, the latter secluded high on the upper level of the apse, barely visible to a person on the ground without a telephoto lens or field glasses. Thus, as is true also of Autun's and Freiburg's defecating gargoyles (plates 47 and 48), the most shocking antics occur out of immediate public view.

Elsewhere, gargoyles consist of a woman attacked (or embraced—in none of these cases does she appear to resist) from behind by a monster whose mouth serves as the waterspout. On the Church of Saint Patrick in Patrington, England, a laughing demonic creature puts his arms around a young lady, who barely notices his presence. On the south side of York Minster, a leering horned monster surrounds the body of a small woman. Perhaps demons carry off these women in punishment for the vanity of their fashionable attire.

Near this Minster monster is a gargoyle in the form of a woman with a frog on her head and a serpent winding around her body (plate 56). The biblical book of Revelation (16:13–14) says: "And I saw three unclean spirits like frogs come out of the mouth of the dragon, and out of the mouth of the beast, and out of the mouth of the false prophet. For they are the spirits of devils." The frog was

frequently used in medieval art as a symbol of the devil. The serpent, going back to the temptation of Eve, was another standard medieval symbol of the devil; here the serpent wraps around the woman's body, much as it is often shown wrapped around the tree trunk in the Garden of Eden.

Perhaps the meaning of these examples of women with a goat or monkey or demon or frog and serpent is connected with the fact that the medieval clergy encouraged the criticism of women; aspects of their behavior and attire (such as hennins—high conical or cylindrical hats—and trailing trains) were often denounced from the pulpit. Subjects satirizing women are notable among the 198 gargoyles at the Parish Church of Saint Andrew in Heckington, England, which include a dog-headed monster carrying off a fashionably dressed woman. But the majority of human gargoyles are male; if gargoyles, as a whole, were intended to criticize and chastise their subjects, more men than women have been reprimanded.

Some gargoyles are shaped like humans but have bestial characteristics, such as excessive hairiness or animal extremities. For example, at York Minster a nude human with animal paws seems to wail with woe over his hybrid condition (plate 57). A race of "people" described in ancient sources and accepted as real in the Middle Ages

56. Woman with frog *and serpent, south side, Minster (Cathedral Church of Saint Peter), York, England.*

are known as the wild men and women of the woods, usually referred to simply as "wildmen." Often depicted in medieval art, they are humans who have gone beyond hairy to frankly furry. Several gargoyles shown with long hair, beards, and furry bodies, such as one holding a club on the west facade of the Old Cathedral of Senlis, France (plate 58), represent wildmen.[12]

Wildmen were regarded as degenerations of humans who had allowed the beast within to appear.[13] Medieval artists also depicted sinners who had succumbed to temptation as transformed into animals, which were considered lower forms of life. This may explain why some gargoyles are mostly human but appear to be metamorphosing into animals. One human, who is literally pig-headed, has been muzzled in the cloister beside the Old Cathedral of Saint-Etienne in Toul, France (plate 59). A gargoyle in the cloister beside the Old Cathedral of Utrecht might be described as catty (plate 61). At the Church of Saint Gommarus in Lier, Belgium, a gargoyle seems to express distress over his condition; although his body is human, his head is that of a monstrous beast (plate 60). These gargoyles may have been intended to intimidate potential sinners by threatening them with the results of sin. Humans and animals, normally separated, are combined; a

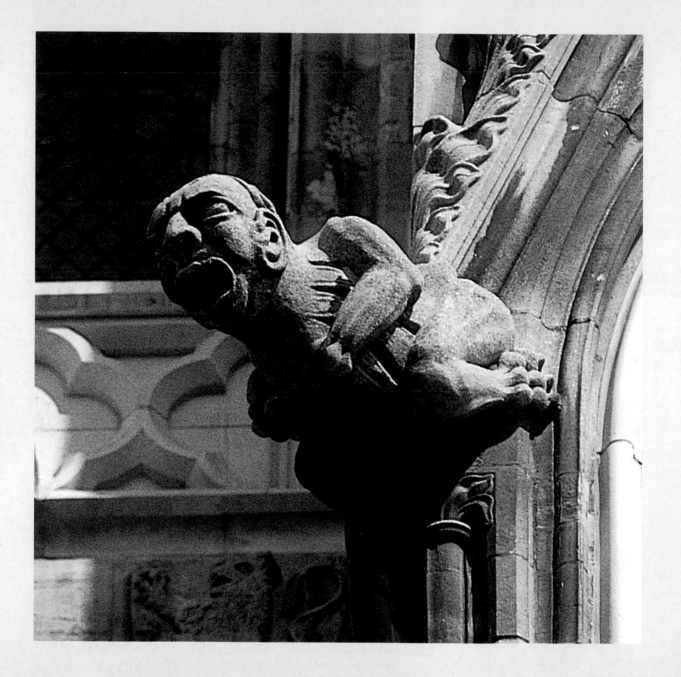

law of nature has been inverted—and thereby perverted. God's division between humans and animals has been transgressed, representing physical and spiritual disorder.

Also regarded in the Middle Ages as part of humankind were the so-called monstrous races, which included some human-plus-animal combinations. Like the wildmen, they have lineages traceable to antique literary sources, beginning with their mention by Herodotus (c. 490/480–c. 424 B.C.) and Ctesias (writing c. 400/398 B.C.). Monster status was attained by anatomical loss or gain. For example, the Cyclopes have only one eye, located in the center of the forehead. The Sciritae lack noses. The

OPPOSITE: 57. *Man with animal paws, Minster (Cathedral Church of Saint Peter), York, England.*

58. *Wildman, west facade, Old Cathedral of Notre-Dame, Senlis, France.*

Blemmyae have no heads at all; their facial features are found on their chests. (A variation is offered by the Epiphagi, whose eyes are on their shoulders.) Other monsters may have one body part enlarged. For example, the Panotii have ears so enormous that they can be flapped to fly or used like blankets to keep their owners warm. The Amyctyrae have either lower or upper lips so large

59. M*uzzled pig-headed man, cloister beside Old Cathedral of Saint-Etienne, Toul, France.*

that they can be used as umbrellas. The Sciapods have only one foot, but it is so large that in sunny weather they lie on their backs and raise their big feet aloft as parasols. Alternatively, an animal part may be substituted. For example, Hippopodes have horses' hooves instead of feet, and the dog-headed Cynocephales communicate by barking.

A number of these anatomical anomalies are

60. Monster-headed man, Church of Saint Gommarus
(Sint-Gummaruskerk), Lier, Belgium.

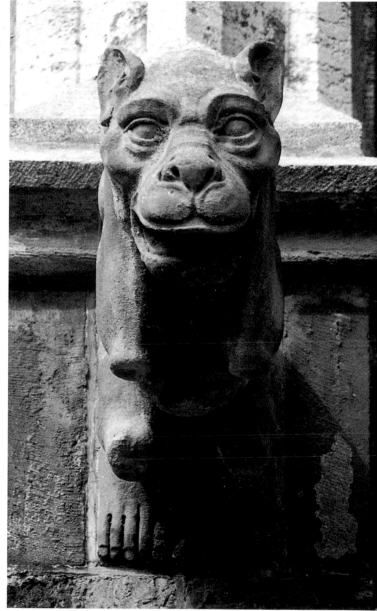

RIGHT: 61. Feline-headed man, cloister beside Old Cathedral
(Domkerk), Utrecht, the Netherlands.

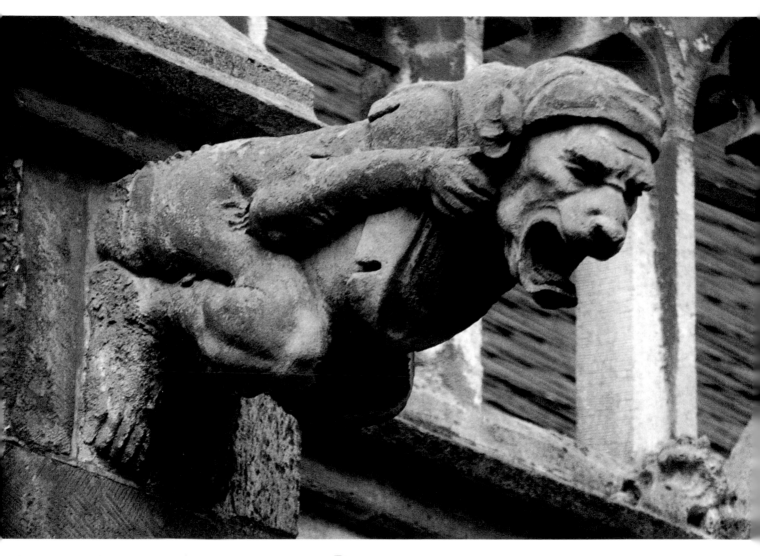

62. *Partially clothed dog-faced*
man, cloister beside
Old Cathedral (Domkerk),
Utrecht, the Netherlands.

carved on the celebrated twelfth-century tympanum depicting the Mission of the Apostles (Acts 11:9–11) on the Church of Sainte-Madeleine in Vézelay, France. Christ is shown instructing his apostles to spread his word to all the different peoples—including the monstrous races—believed to live in the distant parts of the earth. More of the monstrous races, as well as other monstrosities, are depicted on the *Mappa Mundi* ("map of the world"), probably made in late-thirteenth-century England.[14] In addition to the races already mentioned, the *Mappa Mundi* depicts the Gangines, whose only nourishment is the scent of apples; the bat-eared people; the gray-eyed race, whose sight is most acute at night; and others.

Given the apparent quest for variety in gargoyles, the monstrous races would seem to have been a sufficiently unnatural subject to have intrigued the gargoyle carvers. And, indeed, gargoyles with some of these characteristics do exist, such as the nearly nude man with a dog face—a sort of Cynocephale—in the cloister of the Old Cathedral of Utrecht (plate 62). But it is not at all certain that these, or any other gargoyles, were intended to represent a specific monstrous race. Given enough imaginative combinations of different body parts among gargoyles, chances are that some of the results would resemble some of the many monstrous races. Also

arguing against the interpretation of certain gargoyles as intentionally representing members of the monstrous races is the fact that the races were usually depicted in groups, the better to flaunt their anatomical oddities, as at Vézelay, on the *Mappa Mundi*, in manuscripts, and elsewhere. But no comparable assembly among gargoyles is known today.

Another type of "person" that appears frequently in medieval art (especially of the Romanesque and Gothic eras) is the "green man," also referred to as the "leaf man" or Jack-in-the-Green, represented by a man's head surrounded by foliage and sometimes sprouting branches from his mouth or even nose. Generally regarded as a survivor of pre-Christian imagery, the green man is one of the many traces of pagan faiths that were absorbed into the medieval church. A symbol of nature, fertility, and rebirth, the image of the green man became part of the celebrations on May Day and on Rogation Days (the three days just before Ascension, observed by fasting, litanies, and sometimes processions, to obtain God's blessing on the crops). The green man was a common sight in medieval street processions—portrayed by a man whose head and shoulders were covered by leaves attached to a wicker frame. Alternatively, it has been argued that green men represent lust or another of the seven deadly sins. The grotesque head surrounded by

foliage at Salisbury Cathedral looks much like a green man (plate 63).

In general, gargoyles carved in the form of the human figure show great concern for variety of physical types, attire, activities, and expression. The rarity—if not absence—of beautiful humans among the medieval gargoyles is notable because it strongly contrasts to much of contemporary Gothic sculpture, in which beauty is stressed and physical proportions are fairly normal or idealized. The distorted human figures that characterize Romanesque art were abandoned by Gothic sculptors—except for their use as gargoyles. In fact, the monstrosities that abound on Romanesque capitals seem to have found a new habitat, in which they flourished as Gothic gargoyles. Thus, the Roman-esque monstrosities survived among the Gothic beauties, but their realm was restricted to the aerial heights of the gargoyles.

Is there an underlying theme to these types of human gargoyles? Perhaps they present two paradigms: diversity and disorder. Interpreted favorably, the variety of human forms is celebrated as a manifestation of God's richly diverse creation. Interpreted negatively, when the typology of the human realm goes wrong, as seen in the combinations of humans and animals contrary to natural order, the result is ugliness and disorder. The medieval penchant for looking at one thing from two opposed points of view, favorable *(in bono)* and unfavorable *(in malo)*, may have helped to give these gargoyles their varied physiognomies.

63. "Green man," facade,
Cathedral, Salisbury, England.

ANIMAL GARGOYLES

Ogs, goats, donkeys, cows, pigs, lions, monkeys, birds, and many other animals were carved as gargoyles—with varying degrees of fidelity to nature. Among the animals native to western Europe that served as models for gargoyles, the dog was depicted with the greatest frequency. Among those that were not native, the lion was most popular. Little distinction was made between animals that actually existed and those that were invented—a dog could just as easily be shown beside a dragon as a lion.

During the Middle Ages people were still close to the animal world; farm, work, and transportation animals had yet to be replaced with machines. Even for the city dweller, the country was not as far away as it is today. On a practical level, animals were either helpers or hazards in daily life—the lamb was dinner and a warm coat; the wolf was neither. Yet animals were also regarded in more subjective

64. Lion, *north side, Parish Church, Thaxted, England.*

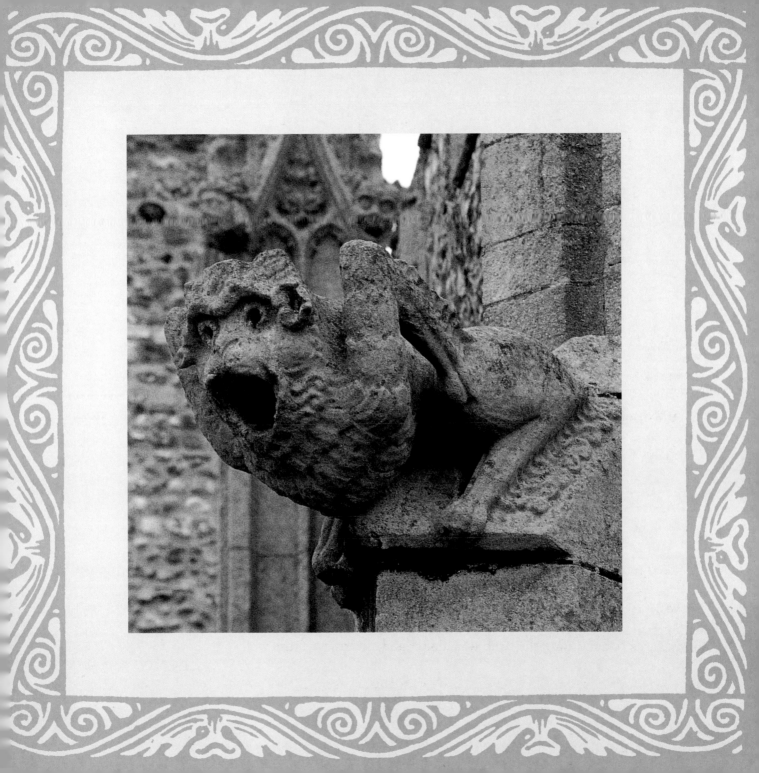

ways, believed to be imbued with special powers and spirits, positive and negative. Human qualities were attributed to animals, or imposed upon them, and the actual abilities of animals often misunderstood. This is illustrated by the trial of a chicken in 1474, found guilty and sentenced to death for laying a basilisk egg—one of many cases of animals brought to trial and even tortured to extract confession. Cats, associated with vanity and witchcraft, and foxes, associated with wiliness and fraudulent behavior, were burned in the Middle Ages (and even the Renaissance) as symbols of the devil. Other animals were usually viewed favorably, either for their actual qualities or for those invented for them. The lion, for example, was employed as heraldic imagery in medieval coats of arms.

An excellent indication of the medieval attitude to animals and the important place of animals in medieval life is provided by the well-known early-thirteenth-century sculptures of bulls (which do not function as gargoyles) high on the towers of Laon Cathedral in France.[1] It was not uncommon to honor saints by putting their images along the roofline of a medieval church; at Laon, the bulls were elevated to a position of comparable importance. This public display of gratitude came from the people of Laon because materials used in constructing their cathedral had been pulled by bulls to the top of the ridge on which the cathedral was built. Such appreciation and affection are unlikely to be bestowed upon the medieval bull's modern equivalent, the tractor.

Just as the use of an animal as architectural ornament may have an explanation specific to its context (like Laon's bulls), the same may be true of one that serves as a gargoyle. For example, the monkey gargoyle in the courtyard of Jacques Coeur's house in Bourges, France, like the exotic trees carved in relief there, presumably refers to Coeur's extensive travels. The monkey's presence was probably due not to gratitude (as with Laon's bulls) but to fascination with an animal unfamiliar to western Europe.

Information known during the Middle Ages about animals, real and imaginary, was summarized in the text and illustrations of the bestiary (or "book of beasts")—a compilation of fact and fiction. Although referred to generically as "the bestiary," there were many different bestiary manuscripts, similar but not identical in content. Bestiaries assign moralistic or religious meaning to almost every creature discussed (many of these meanings are negative; an animal was often used to symbolize behavior that people were to avoid rather than to emulate). It is significant that the popularity of bestiaries coincides chronologically and geographically with that of gargoyles, which form a sort of stone bestiary of their own.

Like bestiaries, the Bible was a source for ani-

mal symbolism, and again, the animal was often shown in a negative light. Little distinction was made in the Bible between real and imaginary creatures. Psalm 22, for example, cites as threatening not only bulls and dogs but unicorns as well.

Outside of bestiaries and the Bible, but inside the church, images of animals were used as vehicles for satire and religious commentary during the Middle Ages. Perhaps the most blatant example, depicted with some frequency on misericords and elsewhere, is a fox, dressed as a monk or priest, preaching to a flock of geese and luring his congregation closer and closer with his words until he is able to snatch a goose to eat. The moral is that the foolish are seduced by false doctrine.[2] Although clearly anticlerical, such images would not have been directed at the church that paid the carver but at the Lollards, followers of John Wycliffe, who sought church reform in fourteenth- and fifteenth-century England.

The fox and goose also refer to the wandering friars who preached to the common people, often criticizing the regular orders and the clergy for their wealth and corruption. Gargoyles may have been used to tell this tale, too. Is that the wily fox preaching on the Cathedral of Saint Rumbald in Mechelen, Belgium (plate 65)? And is that a chagrined goose on the Cathedral of Saint John in Den Bosch, the Netherlands (plate 81)? Thus, some gargoyles on

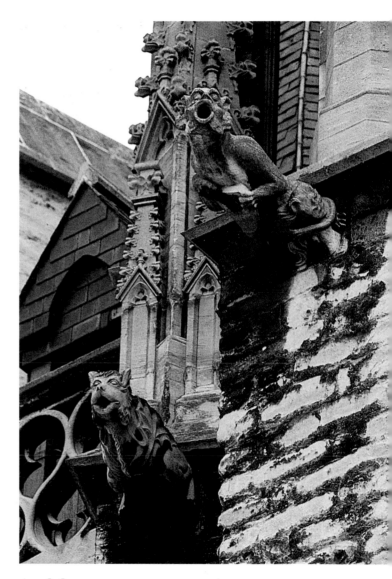

65. *Monstrous gargoyle (top) and foxlike gargoyle (bottom), north side, Cathedral of Saint Rumbald (Sint-Romboutskathedraal), Mechelen, Belgium.*

66. Lion, Cathedral,
Lichfield, England.

the church exteriors might have served to remind people of the morals of the didactic stories they had heard preached inside.

Lions as well as leonine beasts were frequently used as gargoyles. Indeed, among all animals—familiar, foreign, or fabulous—the creature most often depicted in medieval art was the lion. Known from antiquity as the "king of beasts," the lion was shown by medieval artists to be the first animal on and off Noah's ark and was always the first animal described in bestiaries. On the Parish Church of Thaxted in England, an authentic medieval lion gargoyle, its shapes weathered and softened over the centuries, remains unusually animated and appears ready to leap off a buttress (plate 64). At Lichfield Cathedral in England, a more recently carved and more realistically recorded lion crouches as if about to spring, seemingly uttering a low growl through clenched teeth (plate 66). His perfectly coiffed mane is very different from the cascading unruly mane of his companion (plate 67), offering a contrast in the styles of two different sculptors working on the same building and portraying the same subject.

To medieval artists, who had little opportunity for firsthand contact with lions, their distinguishing feature was the mane, used both for lions and lionesses. Extremely regal is the lion on the facade of Orvieto Cathedral in Italy (page 2). This highly

67. Lion, Cathedral, Lichfield, England.

realistic gargoyle is the work of an Italian sculptor still faithful to the classical tradition. A contrast in anatomical accuracy and behavior is provided by a leonine hybrid gargoyle on the facade of the Church of Notre-Dame-des-Marais in Villefranche-sur-Saône, France (plate 68), for his feet are not paws but hooves—one of which is being attacked by a little dragon, symbol of sin. With his other hoof, the lion tramples on the dragon, which he seems to treat almost as one would a playful but bothersome puppy.

The lion was adopted into Christian iconography as, above all, a symbol of Christ—the Lion of the Tribe of Judah. The lion's characteristics were linked to (or invented to correspond with) those of Christ. According to the bestiaries, the lion would erase his tracks with his tail, a "fact" that was connected with Christ's ability to elude the devil. Bestiaries also claimed that the lioness gives birth to dead cubs, which are resurrected three days later by the father lion—a parallel to the resurrection of Christ by his Father. Said never to close his eyes (even in sleep), the lion was an emblem of vigilance; thus, lions appear on tombs or beside entryways to churches, and lion heads were used as door knockers. Lions were said to be faithful to their spouses and loyal to humans who had helped them—

68. Lionlike gargoyle stepping on small dragon, Church of Notre-Dame-des-Marais, Villefranche-sur-Saône, France.

such as Saint Jerome, who removed a thorn from a lion's paw. The lion does not become angry unless wounded, spares the fallen, and never overeats. The great popularity of the lion during the Middle Ages; his almost universally favorable symbolism as vigilant, valiant, regal, and powerful; and especially his association with Christ made him a favorite subject for gargoyles.

Only infrequently was the lion shown in an unfavorable light. In the later Middle Ages, when the seven deadly sins were associated with animals (and linked to parts of the human body), pride was associated with the lion (and the head). (Envy was associated with the serpent and the eyes; anger with the wild boar and the heart; sloth with the ass and the feet; greed with the wolf and the hand; gluttony with the bear and the belly; and lust with the pig and the genitalia.) Sacred texts often compare the devil to animals, including the lion. Psalm 22:13 says, "They gaped upon me with their mouths, as a ravening and roaring lion," and continues (22:21), "Save me from the lion's mouth." Psalm 91:13 says the adder, basilisk, and dragon, as well as "the young lion . . . shalt thou trample under feet." According to Saint Augustine, the lion and other animals mentioned in this passage symbolize various aspects of the devil, with the lion representing the Antichrist.

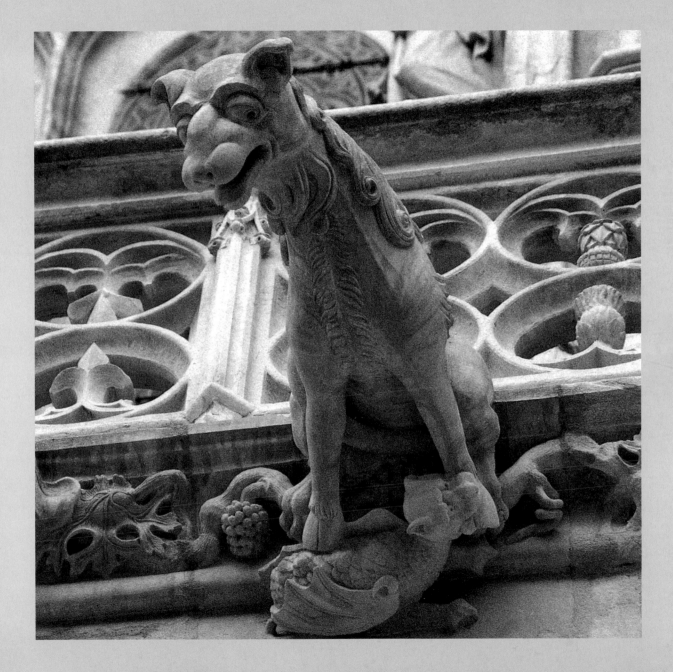

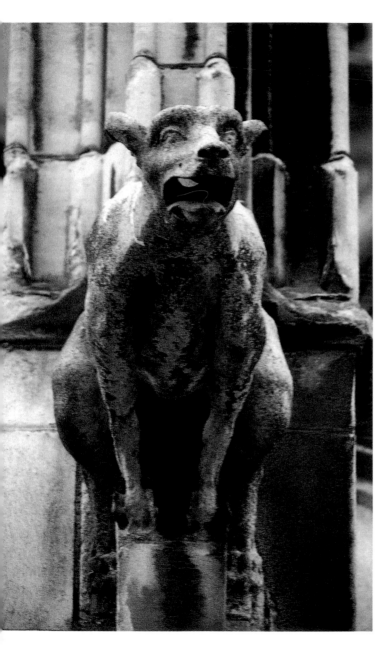

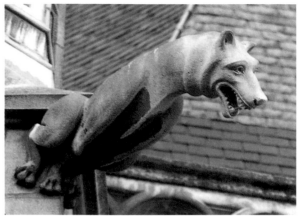

69. Dog, *apse, Cathedral of Saint Rumbald (Sint-Romboutskathedraal), Mechelen, Belgium.*

Dogs, long regarded as man's (and woman's) best friend, have also given faithful service as gargoyles. At the Church of Saint-Urbain in Troyes, France, a gargoyle in the form of a watchdog appears to be always on guard, barking at all who pass (plate 70). At the Cathedral of Saint Rumbald in Mechelen, a sleek shepherd or Great Dane gargoyle, with pointed ears and powerful body, seems to bare his sharp teeth at the passerby (plate 69). Nearby, on the apse of this cathedral, a retriever, identified by his hanging ears and long fur, looks as though he waits patiently; perhaps he protects the little bust-

LEFT: 70. Dog, *Church of Saint-Urbain, Troyes, France.*

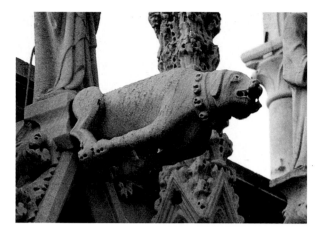

71. Dog, *Church of Santa Maria della Spina,*
Pisa, Italy.

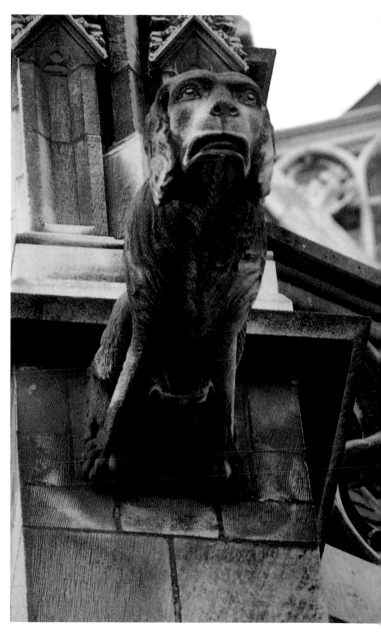

length figure between his paws (plate 72)—bestiaries laud dogs especially for loyalty to their masters. A dog gargoyle at the tiny Church of Santa Maria della Spina in Pisa, Italy, looks like someone's pet; hardly fierce, he seems to bark to the jingling of his belled collar (plate 71). His anatomy is inaccurate, even though the artist would presumably have had easy access to a live model. In contrast, realistic and characteristically canine behavior is recorded by the dog gargoyle on the House of Jacques Coeur in Bourges, shown scratching himself behind the ear (plate 14).

RIGHT: 72. Dog, *apse, Cathedral of Saint Rumbald*
(Sint-Romboutskathedraal), Mechelen, Belgium.

Dogs, said to be the only animals able to learn to recognize the sound of their names, are noted in the bestiaries and other medieval sources for their wisdom and ability to reason. Guardian of homes and their inhabitants, as well as of animal flocks, the dog symbolizes the priest who cares for Christian followers and drives away the devil. But dogs may also be used as negative examples. The story of the dog carrying meat in his mouth, which he sees reflected in water and greedily drops as he tries to get the reflection, is compared to the devil: the preacher must "turn aside the ambushes of the devil, lest he seize God's treasure, namely the souls of Christians, and carry it off."³

Various other domesticated animals were used as gargoyles. A highly realistic (and restored) ram at Reims Cathedral in France kneels to spit rainwater (plate 73). The curly-horned ram with unusually long legs at the Collegiate Church of Sainte-Waudru in Mons, Belgium, appears to be somewhat fiercer (plate 74). Bestiaries say

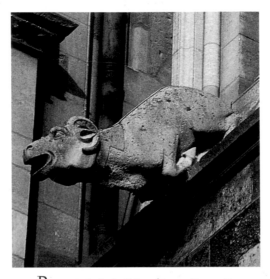

73. Ram, *Cathedral of Notre-Dame, Reims, France.*

that the ram, as leader of the flock, is analogous to the princes of the Church leading the Christian people. Rams were compared to the Apostles because, just as the rams butt their powerful heads together, so the Apostles "always overthrow whatever they strike"— their preaching breaks down superstitions and destroys idols.

A goat gargoyle on the Schöner Brunnen, a fountain in the Hauptmarkt of Nuremberg, Germany, is so realistic in anatomy and so characteristic in posture that the viewer can easily imagine the sound of his bleating (plate 75). Seen in a favorable light, the goat was a symbol of Christ because just as the goat is pastured in the valleys so Christ is pastured in the Church, fed by the good works of Christians. Because of the acuity of the goat's vision, which allows him to "see everything and know men from afar," bestiaries say the goat is like God in being all knowing. The wild goat is the symbol of the wise preacher because, just as the goat can distinguish which

OPPOSITE: 74. Ram, *Collegiate Church of Sainte-Waudru, Mons, Belgium.*

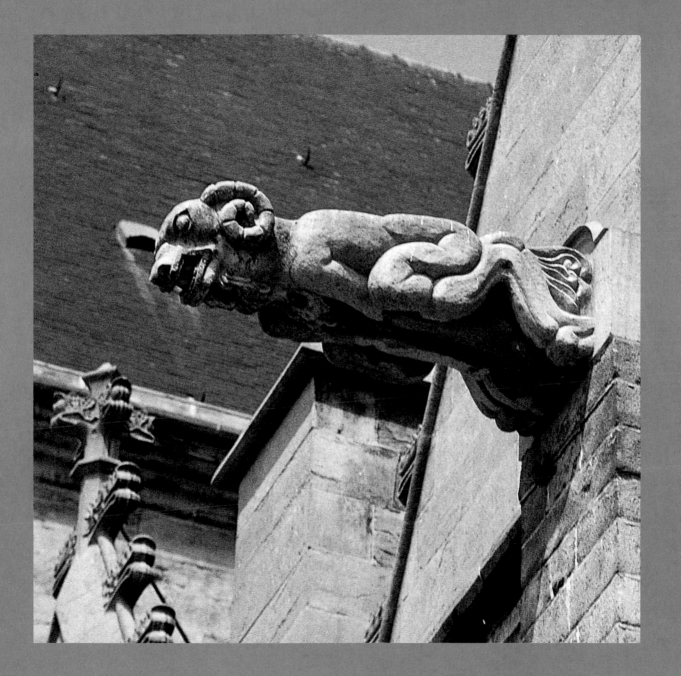

plants are good to eat from those that are bad, so a preacher can distinguish good ideas from bad.

In a less favorable light, male goats, according to bestiaries, are chronically lustful. "The nature of goats is so extremely hot that a stone of adamant [diamond], which neither fire nor iron implement can alter, is dissolved merely by the blood of one of these creatures."[4] Aspects of

75. Monkey and goat, Schöner Brunnen, fountain in Hauptmarkt, Nuremberg, Germany.

OPPOSITE: *76. Braying donkey or ass and angry lionlike monster, south side, Cathedral, Strasbourg, France.*

the goat's anatomy—horns, tail, and cloven hooves—were standard features in depictions of the devil.

The goat on the Schöner Brunnen has a monkey companion, who is preoccupied with eating, as if he had just obtained a piece of fruit in the market square and washed it in the water of his fountain. Artists living in medieval western Europe had little contact with monkeys (or apes,

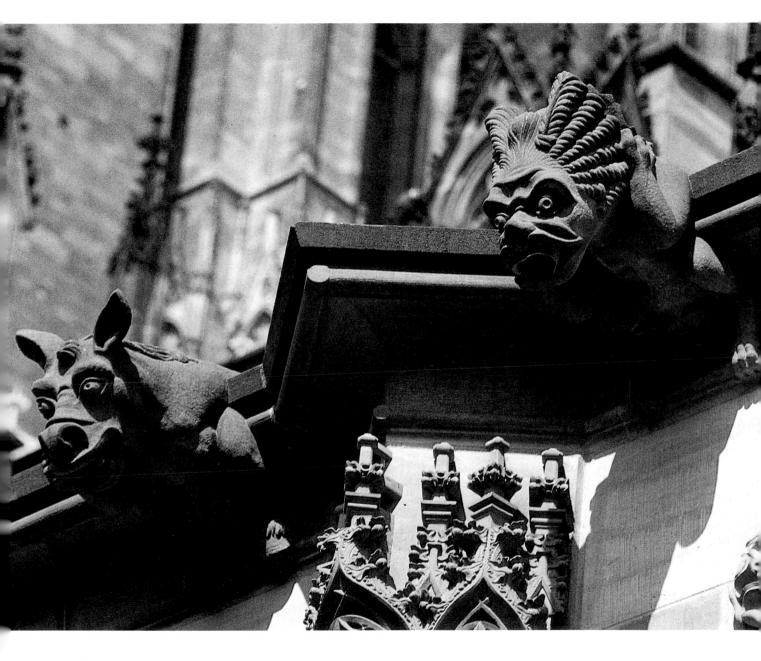

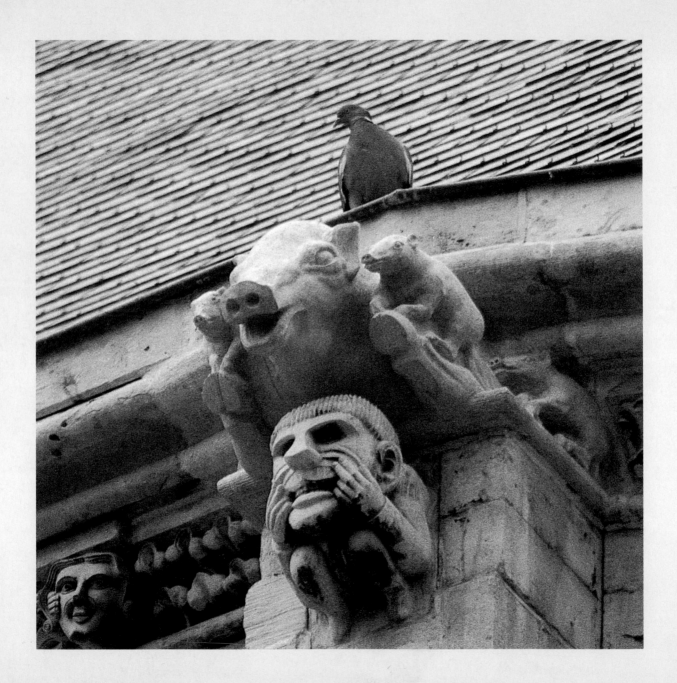

chimpanzees, gorillas, orangutans, or gibbons), but that did not prevent them from depicting these animals. The monkey's physical similarity to humans and ability to mimic human actions were interpreted as a presumptuous overstepping of nature's hierarchy, which linked the monkey to the devil—the most presumptuous being of all. The monkey was used to symbolize the devil's mockery of God, the sinner in general, and the lower or baser side of humans, as well as cunning, malice, vanity, and lust. As a symbol of the fall of humankind, the monkey is included in many depictions of the Temptation, shown eating the apple and helping the serpent mislead Adam and Eve. Medieval artists sometimes depicted the monkey as chained to the ground, surrounded with half-eaten fruits and nuts representing carnal pleasures. In only a few instances was the monkey shown in a favorable light.[5]

So realistic is the braying donkey or ass gargoyle on Strasbourg Cathedral in France that he seems to distress his neighbor, a lionlike creature who appears to hold his ears (plate 76). Bestiaries describe the ass as a patient but stupid work animal—slow moving, brutish, and lecherous. The medieval view of the ass is made clear by the routine inclusion of this animal, with the ox, in scenes of the nativity of Christ. Based upon Isaiah 1:3, "the

ox knoweth his owner and the ass his master's crib," their presence demonstrates that even these lowly animals recognized the divinity of Christ. The onager (wild ass) was said to recognize the spring equinox, when he would bray once an hour—twelve times during the day and twelve times during the night—signifying that day and night were of equal length. Bestiaries say that, therefore, the wild ass represents the devil because he makes day and night the same, and his braying is compared to the roaring of the devil as he counted the souls he had lost to Christ. Perhaps this explains why the Strasbourg donkey gargoyle brays, and why the lionlike gargoyle (a symbol of Christ?) beside him holds his ears. If this interpretation is correct, it suggests that in some instances the position or sequence of gargoyles had significance.

Hogs and pigs were not included in bestiaries and only rarely depicted in medieval art. However, a modern pig gargoyle, notably realistic and flanked by piglets, smiles above a medieval-style mouth-puller on the Church of Notre-Dame-de-la-Chapelle in Brussels (plate 77). Although viewed favorably in other cultures, in medieval western Europe the pig was a symbol of sins of the flesh. The symbol of Saint Anthony, the pig refers to his triumph over the sins of sensuality and gluttony. Pigs and

77. Pig and piglets with mouth-puller, Church of Notre-Dame-de-la-Chapelle, Brussels.

other animals were believed to be protected by Saint Anthony; a "Tantony pig" still refers to the smallest of the litter.

Gargoyles were often carved in the form of birds, their aerial habitat making them natural choices for the gargoyles' high perches. Sculptors also used the shapes of their feathers and wings to create decorative patterns, as demonstrated by a bird on the Church of Saint Gommarus in Lier, Belgium (plate 78). Another bird gargoyle, with bulbous talons and a beak so weathered that it now looks like a nose, adorns the Old Cathedral of Utrecht in the Netherlands (plate 79). These and other examples make clear that an Audubon-like accuracy is not characteristic of ornithological gargoyles. Yet differences between species are indicated—at Lichfield Cathedral, for example, a bird flaunts a distinctive plumed crest (plate 80). That birds were not exempt from gargoyles' characteristic expressiveness is demonstrated by a goose with

78. *Bird, Church of Saint Gommarus (Sint-Gummaruskerk), Lier, Belgium.*

cocked head at the Cathedral of Saint John in Den Bosch (plate 81).

If there is an iconography to this aviary, it is certainly unclear and probably complex. Some birds were regarded favorably during the Middle Ages. The eagle, for example, is the symbol of Saint John the Evangelist and was said to renew itself by looking into the sun—a parallel to rebirth through baptism. Other birds were regarded unfavorably. Male partridges were said to be so lustful that they would mount other males, and the females were said to steal the eggs of other birds, just as the devil had tried to rob God of his child.

Knowledge of medieval animal symbolism as a whole—derived from bestiaries, other medieval literary sources, the Bible, and popular tales—strongly suggests that animals seen as gargoyles, as well as those in other contexts, had transcendent meaning to the people of the Middle Ages. If one knew the code, it was possible to learn about the invisible through the visible—a major point

OPPOSITE: 79. *Bird, south side, Old Cathedral (Domkerk), Utrecht, the Netherlands.*

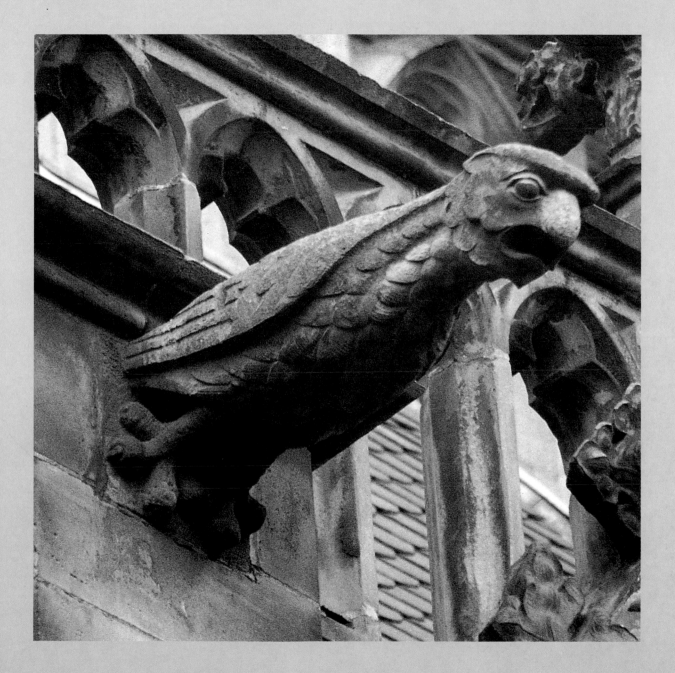

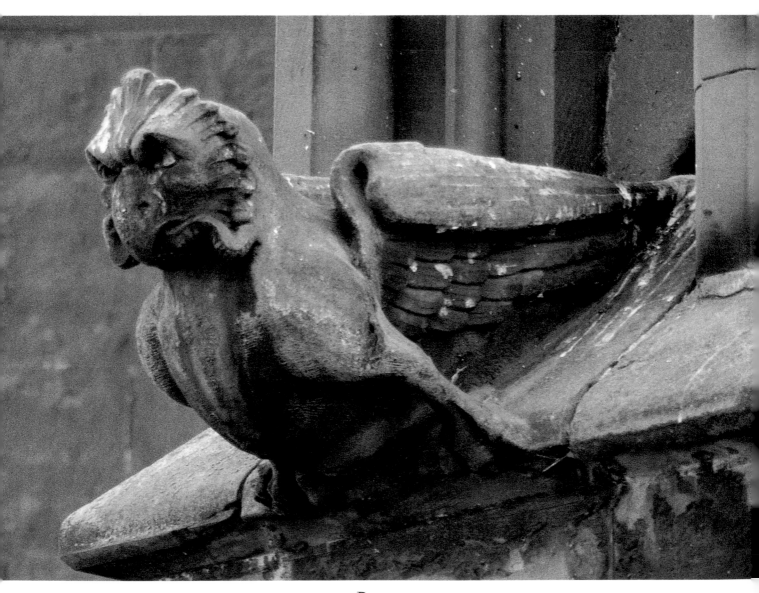

80. Bird, Cathedral,
Lichfield, England.

of medieval religion. Today, however, the difficulty is deciphering that once familiar code. Medieval sources, although important aids in interpreting animals in general, do not provide a clear explanation for the meaning of individual gargoyles. Like animals used in other contexts in medieval art, animal gargoyles are subject to a multiplicity of interpretations. That multiplicity is made more difficult to decipher by the use of seemingly contradictory interpretations; as just noted, the lion, dog, and other animals could have both positive and negative connotations. Nonetheless, one view was likely to dominate. Thus, the lion and dog are usually good —beasts interpreted as symbols that represent the Divine; the monkey and pig are usually bad—beasts with qualities contrary to the Divine.

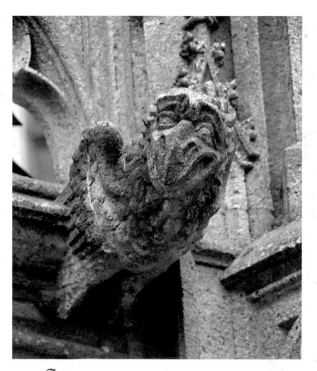

81. Goose, Cathedral of Saint John (Sint-Janskathedraal), Den Bosch, the Netherlands.

GROTESQUE GARGOYLES

A GREAT MANY GARGOYLES BELONG TO unknown species; some are among the most splendid specimens of fantastic fauna ever invented. Grotesque gargoyles, however, constituted only part of the gene pool for the enormous monster population in the Middle Ages; most of the animals created by medieval artists, no matter what media they worked in, were imaginary creatures. Medieval monstrosities—defined here as any kind of fauna that does not conform to the norm for a species—can be grouped into two broad categories. Some combine parts from different animals; others are part animal and part-human. The latter were classified as animals and, hence, differentiated from the monstrous (but still regarded as human) races discussed earlier.

Some of the fantastic creatures found in medieval art may have been the result of confusion with actual animals. For example,

82. *Attacking monster with wings, north facade, Cathedral of Notre-Dame, Paris.*

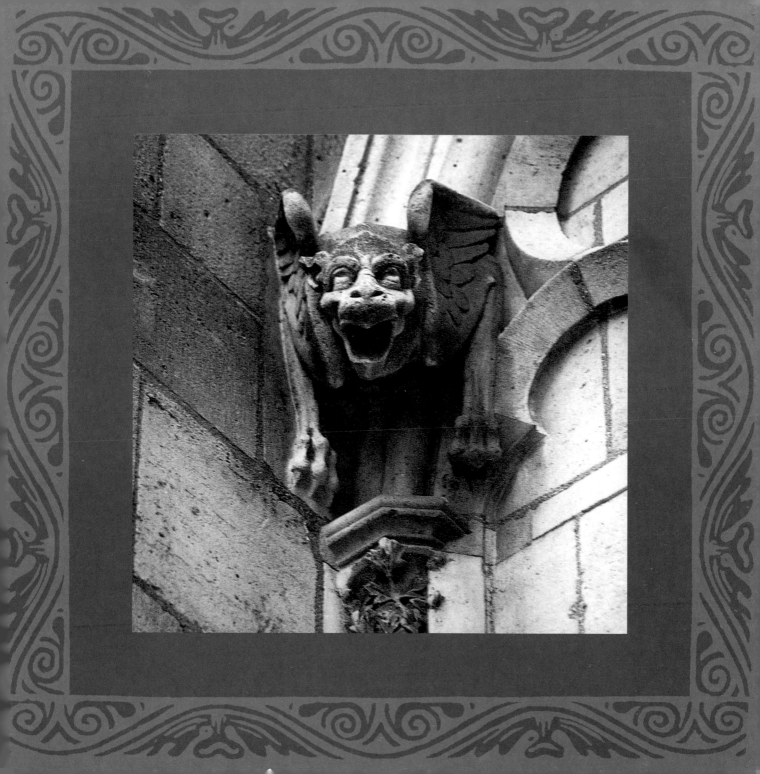

the description of the unicorn, a four-legged animal with a single horn centered on its forehead, is the same as that of the rhinoceros. Bestiaries, in fact, note that the unicorn was called *rhinoceros* by the Greeks. The horns of the unicorn and the rhinoceros were both claimed to have powers against diseases and poisons, and both animals, it was said, could be caught only with the complicity of a virgin girl.

Other monstrosities may have been the result of exaggerating the qualities of an actual creature. For example, it was claimed that, when frightened, the *parandrus* or *parander* (described in bestiaries as being the size of an ox, with ibex footprints, a stag head with branching horns, and bear fur) could camouflage itself by taking on the color of whatever was nearby—be it a white stone or green foliage. Even though white may be beyond the palette of the chameleon and green is not among seasonal changes in hue of the reindeer's coat, nature does give some animals the parandrus's skill.

Some animals that look monstrous to us today may have been intended to represent real animals, but animals that the medieval artist working in western Europe had never actually seen. Only on rare occasions, such as the visit of a traveling menagerie, would an artist have the opportunity to observe animals not native to the area. The lion in the famous drawing said to be "from life," made by Villard de

Honnecourt in the 1230s in France (now in the Bibliothèque Nationale, Paris, Ms. Fr 19093), is believed to have been part of Emperor Frederick II's menagerie. The elephant drawn by Matthew Paris in 1255 in England (now in Corpus Christi College, Cambridge, England, Ms. 16) had been a gift to the menagerie of King Henry III of England from King Louis IX (Saint Louis) of France. But what was the artist to do when required to depict Jonah's whale?

Some monstrosities may have had their source in mistranslation or linguistic confusion. The medieval ant-lion *(mirmecoleon)*—said to have the face or forepart of a lion and the back part of an ant—is perhaps the ultimate example of an improbable amalgamation.[1] It is hardly surprising that this invention is not found among the gargoyles, for it seems to have been the result of a literal translation of the name of an insect known as the myrmeleon, which derives from a combination of the Greek *myrmex* (ant) and *leon* (lion).

The lapses in logic in the design of such animal amalgamations mirror the multitude of illogical "facts" claimed to be true of imaginary creatures during the Middle Ages. For example, the so-called unicorn horns displayed in England, France, Italy, and elsewhere during the Middle Ages were actually the horns of narwhals—North Sea animals in the walrus family. The difficulty that a unicorn (said to

be the size of a goat) would have had in hoisting a horn six feet long or longer went unnoticed. Another example is provided by the highly valued eggs claimed to be laid by griffins. Never mind that the part of the griffin (a lion with the head and wings of a bird) required to lay the egg was leonine rather than avian—inventories from the twelfth to the sixteenth century include cups made from griffin eggs. And what about the ant-lion might most tax one's credulity? In the Middle Ages, it was the question of whether the animal was a herbivore like its mother or a carnivore like its father. The disappearance of the ant-lion was said to be due to its death from starvation, but this creature evidently required too much even of medieval credulity and gradually disappeared from literature as well.

In defense of the medieval acceptance of the seemingly impossible animal, it must be said that nature also provides some highly imaginative inventions. Consider those that metamorphose, such as the tadpole that begins life in water but becomes a frog that can live on land or the caterpillar that transforms itself into a cocoon and then a butterfly able to fly away. Prototypes for the gargoyles' implausible anatomy are the duck-billed platypus, a burrowing mammal with fur that is aquatic, has webbed feet, and lays eggs, or the ostrich, a bird that can grow to be eight feet tall but cannot fly. No won-

der belief in the unicorn persisted into the eighteenth and nineteenth centuries.

A great many implausible gargoyle creatures were invented during the Middle Ages simply by disassembling known animals and humans and reassembling the parts in ways unknown to nature. Among the legions of gargoyles that were conceived in this way, a significant number seem to depict dragons, the devil, and demons.

The dragon was depicted more frequently in medieval art than any other fantastic creature. The word *dragon* derives from the Sanskrit *dric* (which means "to see" and refers to the dragon's ability to destroy with his eyes), as well as from the Greek *drakon* and the Latin *draco*. Since Greek and Roman times, the dragon has been regarded as menacing and destructive. Other animals, such as the lion or griffin, can symbolize both good and bad, but the dragon is always and only evil in Western art.[2]

The devil is most frequently portrayed in the form of a dragon. Before Lucifer revolted against God and was cast out of heaven, he was the most beautiful of all the angels. But when Lucifer fell, he became as ugly as he had once been beautiful, and he changed his name to Satan, which means "adversary" or "opponent." Rarely was a distinction made between the names Lucifer and Satan in the Middle Ages, nor were these terms used uniformly; both

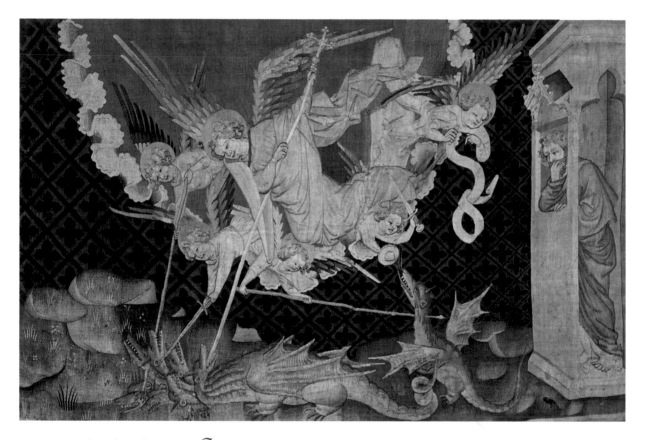

were considered to be the personification of evil, most often known as the devil.

83. Combat of the Angels Against the Dragon, 1377–88. *French, tapestry, woven by Nicolas Bataille of Paris, based on cartoons by the painter Jean Bondol (Hennequin de Bruges). Musée de la Tapisserie de l'Apocalypse, Angers, France.*

angels battle this dragon. That the dragon symbolizes the devil is made explicit in Revelation 20:2

The biblical book of Revelation (12:1–4) describes the woman of the sun being menaced by an enormous dragon with seven crowned heads and ten horns, which tries to devour her infant son; in Revelation 12:7–9, the archangel Michael and his

—"the dragon, that old serpent, which is the Devil and Satan." The Apocalypse described in Revelation is magnificently illustrated in the celebrated tapestry series known as the *Angers Apocalypse*, which was commissioned by Louis I of Anjou, a brother of

King Charles v. In *Combat of the Angels Against the Dragon* (plate 83), Saint John (traditionally believed to be the author of Revelation) watches as the angels led by the archangel Michael plunge from the clouds toward the dragon, piercing it with their long lances and swords in a symbolic triumph of faith over evil. The dragon is depicted as a sort of reddish crocodile with bat wings and seven heads, traditionally interpreted as representing the seven deadly sins.

Bestiaries, too, identify the dragon as the devil. Among the similarities noted are the dragon's crown-like crest, which relates to the devil's status as the king of pride. The dragon's ability to suffocate his victims extends even to the elephant; using his tail to lasso the elephant's legs in a knot, the dragon then kills the elephant by coiling around him. The dragon is compared to the devil because, like the dragon's, the devil's strength is not in his teeth but in his tail—he beguiles by deceit, strangling the deceived in the knots of their sins.

Although the anatomy of medieval dragons is far from standardized, likely to be included are a pair of wings, perhaps indicating the devil's origin as a fallen angel. The wings are membranous (like those of a bat—an animal associated with darkness, chaos, and evil), rather than feathered (like those of a bird or an angel). Dragons are depicted with two or four legs, claws, a long reptilian tail, and a bestial head with long snout, visible teeth, and a fierce expression. Many gargoyles, such as one with batlike wings on the Town Hall of Leuven, Belgium (plate 85), have physical characteristics of dragons. Another dragon gargoyle, on the Collegiate Church of Sainte-Waudru in Mons, Belgium, has impressive webbed wings (plate 84).

Many saints are said to have conquered dragons, the most famous being George of Cappadocia (d. 303). Also symbolizing the victory of good over bad are representations of Christ or Mary standing on a dragon. On medieval tombs, the dragon at the feet of the effigy of the deceased represents the evil this person conquered while alive. In their daily struggles against the forces of evil, the people of the Middle Ages had many guides to show them which path to take to virtue; that so many medieval dragons were conquered held out hope to the faithful that they would overcome their own problems.

According to the strictest tradition, there is only one devil (*diabolos*); demons are the devil's subordinates. The word *demon*, meaning an extremely evil spirit, derives from the Greek *daimon*, but the etymology and original meaning of this word are uncertain.[3] Over the centuries of the Middle Ages the immaterial was made material as an anatomy of the demonic was gradually designed and an iconography of evil evolved. The monstrous nature of the devil's

84. Dragon, *Collegiate Church of Sainte-Waudru, Mons, Belgium.*

OPPOSITE: 85. Dragon, *Town Hall (Stadhuis), Leuven, Belgium.*

outer shape was intended to reveal his inner repulsiveness. The devil and demons are described with great diversity in medieval literature, but there is always agreement on their ugliness. Beauty was believed to be made by God and was therefore good; ugliness, consequently, was evil. God was said to have created all pleas-ant things, and the devil the unpleas-ant ones—evidently including his own appearance.

After Christ fasted forty days in the wilder-ness, the devil tempted him to turn stones into bread, to which Christ responded, "Man shall not live by bread alone" (Matthew 4:1–4). The devil who

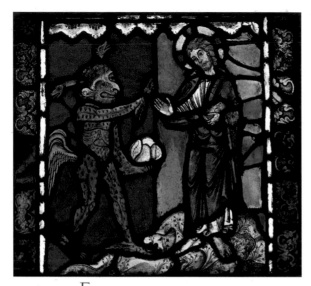

86. First Temptation of Christ, c. *1170.*
Stained glass from the Cathedral of Saint-Pierre et
Saint-Paul, Troyes, France, now in the Victoria
and Albert Museum, London.

tempts him in the stained-glass *First Temptation of Christ* (plate 86) is basically human in shape, but green and furry, with wings on his hips, feathered ankles and wrists, a beak instead of a nose, and serpent heads growing from his head. In the thirteenth century and earlier, devils generally were depicted with feathered wings, as seen here.

In time, the devil became more bestial and the demons proliferated, becoming more macabre. By the fourteenth century, feathered wings were being replaced by bat wings (Dante, in the final canto of the *Inferno,* written c. 1307–14, describes Lucifer's wings as not feathered but batlike). The demons in Andrea da Firenze's *Descent of Christ into the Limbo of the Fathers,* in the Spanish Chapel of Santa Maria Novella, Florence (plate 87), represent this type. The universality of such images of the devil and demons throughout Gothic Europe is suggested by their presence in the Limbourg brothers' *Hell* (plate 15), made for Jean de Berry, a brother of the king of France.

Certain gargoyles share the physical characteristics of the devil and his demons—human in shape but with horns, pointed animal ears, fangs, beard, membranous wings, tail, cloven or clawed feet, nude hairy bodies, and menacing mien. Although depictions vary—individualized and personalized by each artist—a gargoyle with these characteristics would immediately have been associated with the devil and demons by medieval viewers. For example, the expression of a fanged demonic gargoyle lurking on the Town Hall of Bruges, Belgium (plate 88), is intentionally threatening; he appears to open his mouth wide to make room for the potential meals

OPPOSITE: *87.* Andrea da Firenze *(Andrea di Bonaiuto)*
(Italian, active c. 1343–1377). Descent of Christ into the
Limbo of the Fathers *(detail), 1365. Wall painting in the*
Spanish Chapel, Santa Maria Novella, Florence.

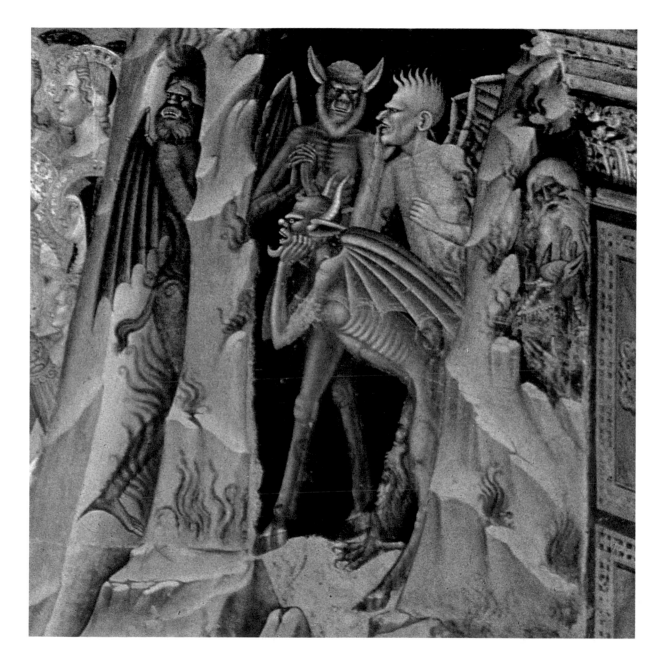

walking below. Equally intimidating is the expression of a gargoyle on the Town Hall of Leuven, grotesque in his ugliness, with prominent fangs, goat beard and ears, wings, and snakelike tail (plate 89). People who pass by the National Bank of Belgium in Leuven are mocked by a gargoyle with a somewhat more human face that takes an identical (and common) pose (plate 90).

The polymorphic physiognomies of the demonic creatures can be explained by the belief that evil is more varied than beauty; indeed, the anatomy of demons is portrayed as far less consistent than that of angels. (The demonic dominates the angelic in the gargoyle population; rare indeed is an angelic gargoyle.) The diversity of physical types given to the grotesque gargoyles may relate to the devil's ability to transform himself. Dionysius the Areopagite (d. 95?), an Athenian judge who was converted to Christianity by Saint Paul, described evil using words such as "a disproportion," "an error," "unlovely," "imperfect," "unreal," "disordered," and "incongruous"[4]—all of which sound like apt descriptions of

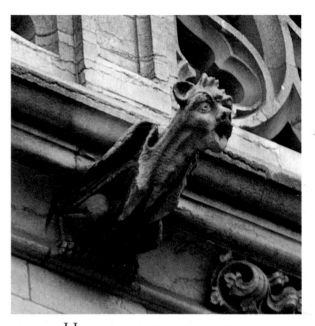

90. Hooting creature, National Bank of Belgium, Leuven, Belgium.

these demonic gargoyles. A striking demonstration of this is offered by a gargoyle on Lichfield Cathedral in England, which has a human face but is fully equipped with horns, fur, wings, and powerful clawed feet (plate 92). The physical disarray of demonic gargoyles defies the natural order, much as the medieval concept of hell was that of a place of disorder and chaos, in contrast to neat and tidy heaven.

All of these monstrous gargoyles (plates 88–90, 92) have wings, supporting the argument that they are intended to represent fallen angels. While the

OPPOSITE, LEFT:
88. Demonic creature, Town Hall (Stadhuis), Bruges, Belgium.

OPPOSITE, RIGHT:
89. Demonic creature, Town Hall (Stadhuis), Leuven, Belgium.

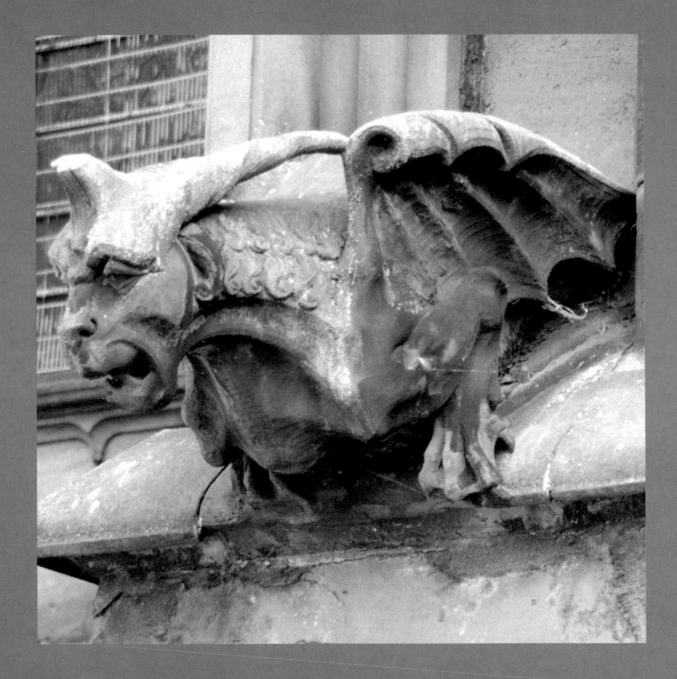

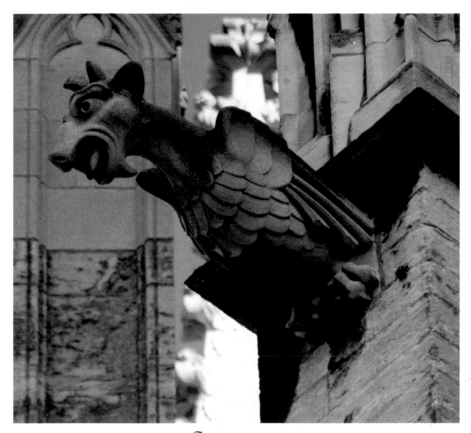

91. G*oat head on bird body,*
Cathedral of Saint Rumbald
(Sint-Romboutskathedraal),
Mechelen, Belgium.

OPPOSITE: *92.* H*uman face*
on monstrous composite body,
Cathedral, Lichfield, England.

lively Lichfield gargoyle appears potentially capable of taking wing, one on Notre-Dame in Paris seems to be emerging from the stone already in mid-flight (plate 82). In fact, gargoyle carvers seem to have had special affection for applying wings to many of the creatures they created, perhaps to aid them in attaining their aerial roosts. Thus, above our heads in the air at the Netherlands can be seen a winged goat at the Cathedral of Saint Rumbald in Meche-len, Brussels (plate 91), a winged dog at Milan Cathedral (plate 93), a hare the Old Cathedral of Utrecht in the (plate 95), and a flying fish at the Church of Saint Gommarus in Lier, Belgium (plate 94).

Other winged creatures defy any

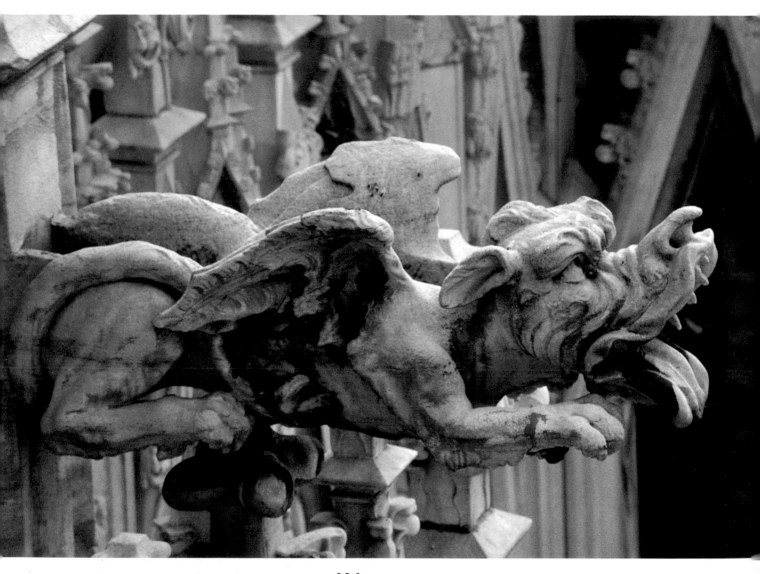

93. Winged monstrous dog,
Cathedral of Santa Maria,
Milan.

The method used to design dragons, the devil, and demons by interchanging body parts from different animals—procreation by reorganization—reached its peak in the Middle Ages, but it had already been widely employed in classical mythology. Certain ancient hybrids persisted in medieval art—the unicorn, satyr, centaur, and griffin—but they were not popular as gargoyles. There are gargoyles that have the requisite body parts to be identified as a descendant of the antique merman, as seen on Milan Cathedral (plate 98), or the mermaid

94. *Flying fish, Church of Saint Gommarus (Sint-Gummaruskerk), Lier, Belgium.*

95. *Winged rabbit, north side, Old Cathedral (Domkerk), Utrecht, the Netherlands.*

form of identification. A delicate gargoyle at the Hôtel de Ville in Brussels, who seems to wear a cape, has bulging eyes that make him look like a frog prince (plate 107). The massive monster in the cloister beside the Old Cathedral of Utrecht (plate 97) is a fitting companion for Laon Cathedral's winged rhinoceros and hippopotamus (plates 13 and 106). And since bird wings were so often added to animals otherwise earthbound, allowing them access to the aerial realm, birds, too, deserve to benefit from the addition of unnatural body parts, as evidenced by the four-legged specimen—better equipped than usual for life on land—perched on Burgos Cathedral in Spain (plate 96).

(plate 100) and siren (plate 99), both on the Town Hall in Brussels, or the satyr on the apse of Cologne Cathedral. But it is not certain that these were actually intended to represent specific ancient mythological creatures. Rather (as was noted to be true of the "monstrous races"), the anatomy of these gargoyles may simply be the chance result of shuffling anatomical

96. Bird with four legs, Cathedral, Burgos, Spain.

OPPOSITE: *97. Winged bovine, cloister beside the Old Cathedral (Domkerk), Utrecht, the Netherlands.*

elements. This is made more likely by the fact that the gargoyle "mermaid" and "siren" are grotesque, lacking the physical beauty of the ancient mermaids and sirens who were said to lure sailors to their doom.

Christian iconography uses animal-human hybrids to symbolize three of the four Evangelists: Matthew is represented by a winged man, Mark

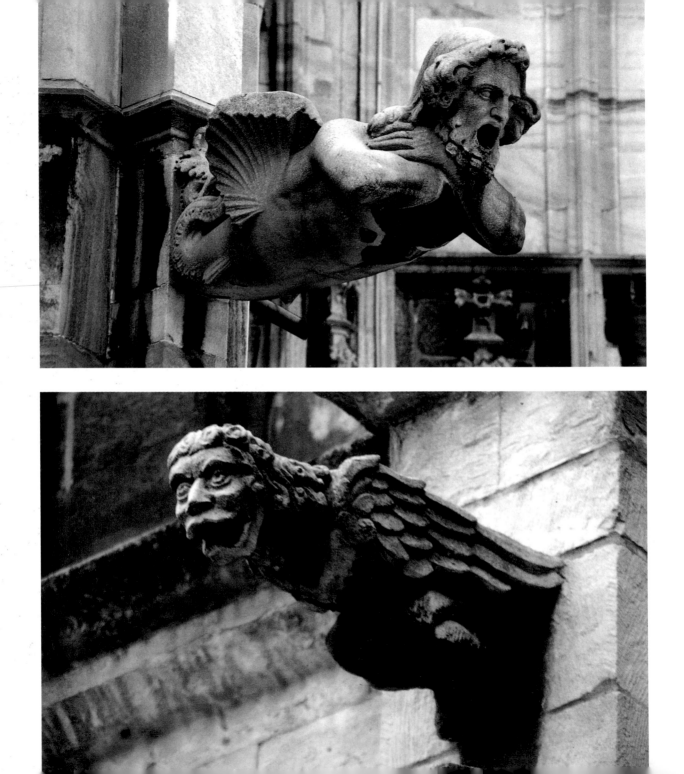

OPPOSITE, TOP: **98.** *Triton/merman, Cathedral of Santa Maria, Milan.*

OPPOSITE, BOTTOM: **99.** *Siren/harpy, Town Hall (Hôtel de Ville), Brussels.*

by a winged lion, and Luke by the winged ox, while John is represented by an eagle. But even when a winged lion, for example, is found as a gargoyle—like those on the facade of the Cathedral of Saint-Pierre in Poitiers, France (plate 41), and the Cathedral of Saint John in Den Bosch, the Netherlands (plate 101)—there is no evidence that it was intended to represent Mark, whose symbol customarily was shown with those of the other three Evangelists and would not have been linked with the irreverent mouth-puller seen in plate 41.

Other animal-human gargoyles bear no resemblance whatsoever to established types. Thus a ram on the Church of Saint-Ouen in Rouen, France, has a human face (plate 102). A human head is attached to an abbreviated animal body, seemingly suffering over having to crouch on such a small support on the Florence Cathedral (plate 103). Conversely, a human body can have an animal head, like the goat-headed man at Strasbourg Cathedral in France, who heckles the humans below while his companion, whose species must be known only to his mother, joins in the fun (plate 104).

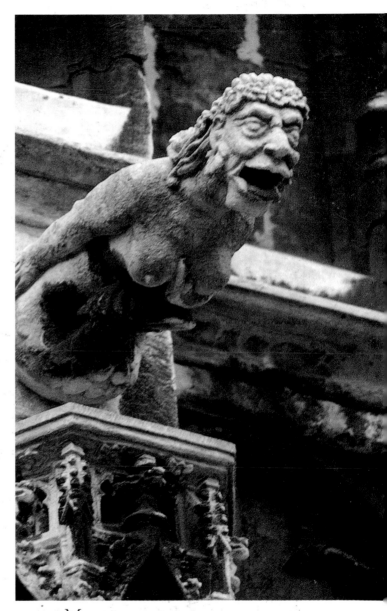

100. *Mermaid, Town Hall (Hôtel de Ville), Brussels.*

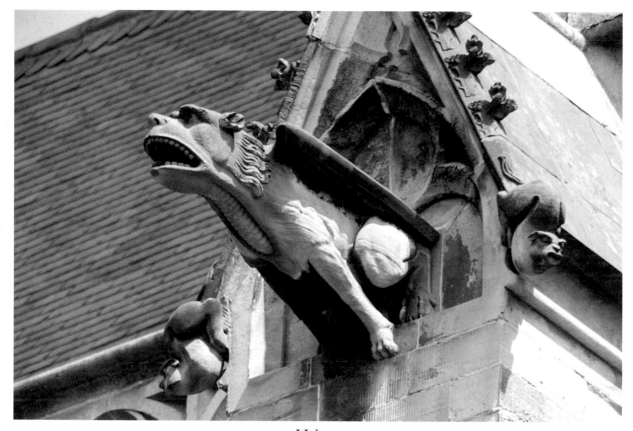

101. W*inged lion, Cathedral of Saint John (Sint-Janskathedraal), Den Bosch, the Netherlands.*

Little about the grotesque gargoyles associates them with the usual late medieval–early Renaissance emphasis on physical beauty and standardization of types. In contrast, grotesque gargoyles are frightening or unnerving. Likely to be misshapen, irregular, or in some other manner unnatural, some of these gargoyles are offensive, even repulsive.[5] Yet others, even with —or perhaps because of—their peculiar and noncanonical proportions, can be quite alluring, even charismatic creatures.

Sculptors of gargoyles seem to have been dissatisfied with the limitations of nature's own inventions and certainly did not regard accurate imitation of actual creatures as obligatory. Rather, nature was a source of inspiration. Just as any motif found in the artist's model book could be copied in

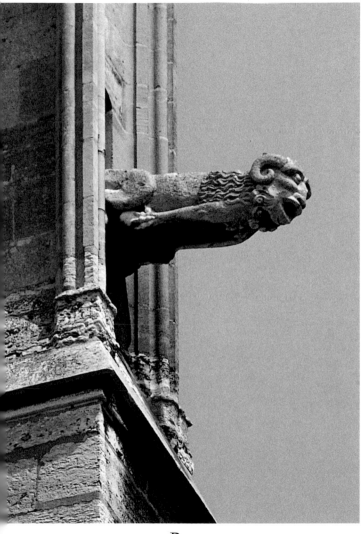

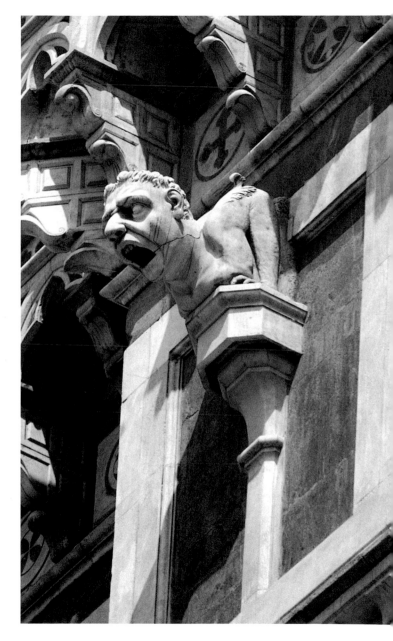

ABOVE: **102.** Ram with human face, south side, Church of Saint-Ouen, Rouen, France.

RIGHT: **103.** Human head on monstrous body, south side, Cathedral of Santa Maria del Fiore (Duomo), Florence.

isolation, so too any part of an actual animal—beak, wings, claws, tail—could be used without the rest of that animal.

It sometimes seems as if there was an ongoing competition to create the most implausible assemblages of unrelated parts. One modern gargoyle on Milan Cathedral has the torso and arms of a man, the head of a duck (with teeth!), and the tail of a reptile; he is evidently equipped for life on land, in air, and in water (plate 105). This creature's conception, using both meanings of the word, could have taken place only within the extremely fertile human imagination. Also modern, at Laon Cathedral in France, are a winged rhinoceros and a winged hippopotamus (plates 13 and 106). Entirely true to the medieval mentality, they would be excellent candidates in a contest for the most profoundly implausible animal—and the least likely to become airborne.

Are grotesque gargoyles evidence of medieval creativity or medieval credulity? The prevalence of monstrosities during this era surely has much to do with ignorance and superstition. Medieval reports of fabulous creatures were as detailed and descriptive as those of actual animals. In art, the dragon that Saint George slays is shown to be as believable as

104. Laughing goat-headed man; monstrous head on human body, south side, Cathedral, Strasbourg, France.

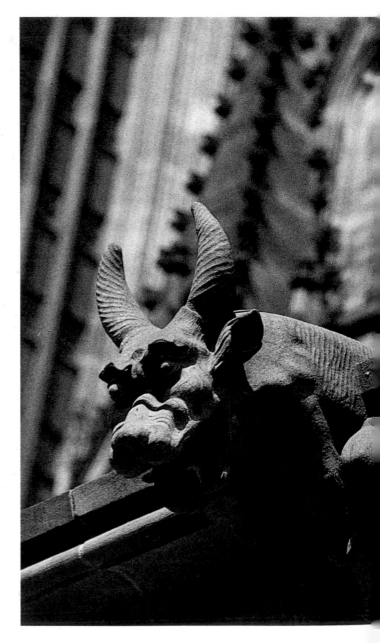

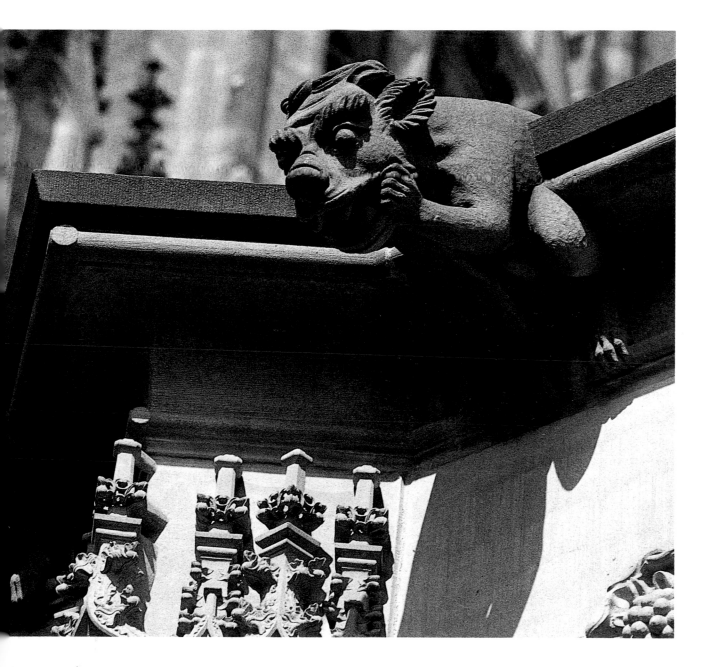

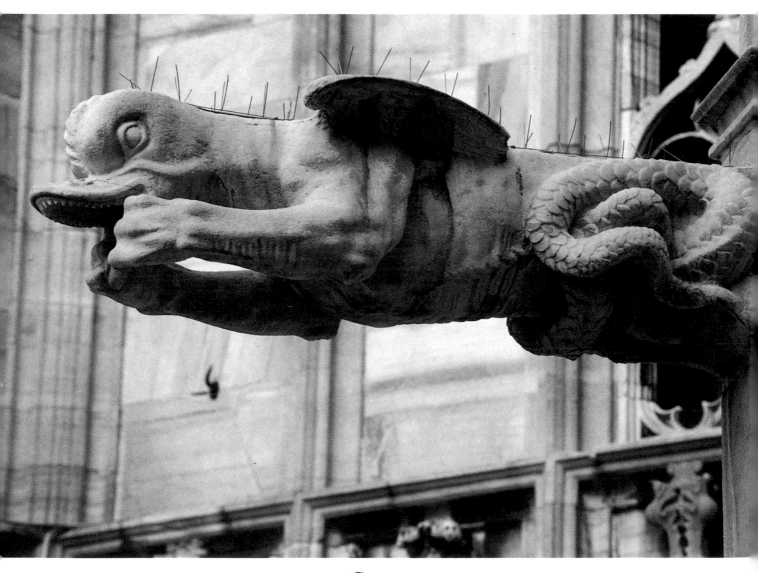

105. Composite creature,
Cathedral of Santa Maria,
Milan.

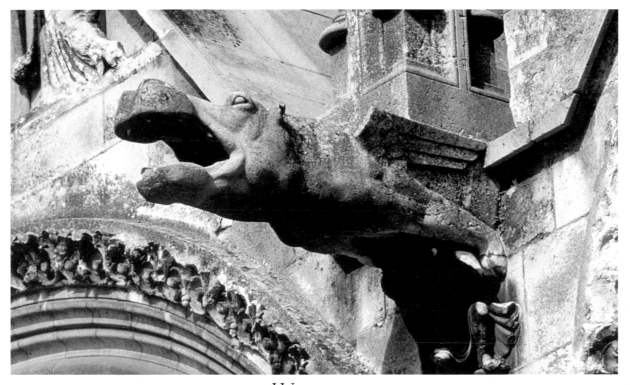

the horse on which he rides. Yet such precise representation of the dragon and other fantastic creatures does not necessarily mean that their existence was believed in literally; during the Middle Ages, emphasis was, above all, on the moral edification a creature pro-

106. Winged hippopotamus, west facade, Cathedral of Notre-Dame, Laon, France.

vided. Gargoyle imagery, like other imagery in medieval art, had little to do with direct observation of the natural world. Medieval artists seem to have preferred the fantastic, or at least the real animal distorted, over the accurately recorded real animal.

NOTES

INTRODUCTION: SOME FACTS AND SOME
CONJECTURES ABOUT GARGOYLES

1. See the comments of the late-nineteenth-century French master restorer of medieval monuments, Eugène Emmanuel Viollet-le-Duc, *Dictionnaire raisonné d'architecture* (Paris: V. A. Morel, 1875), vol. 6, pp. 21–28.

2. Henri Focillon, *Moyen Age: Survivances et réveils* (Montreal: Valiquette, 1945), pp. 89–107, especially p. 99, suggests that Gothic gargoyles should be thought of as a revival of Romanesque spirit.

3. A lead repoussé gargoyle on a fifteenth-century house in Vitré, France, is shown in Viollet-le-Duc, *Dictionnaire raisonné*, fig. 11 on p. 28.

4. At the Cathedral of Saint-Lazare in Autun, France, where most of the gargoyles are restored, even Denis Grivot (author, with George Zarnecki, of *Gislebertus, Sculptor of Autun* [New York: Hacker Art Books, 1961]) told the author that he was not always able to determine the date of certain gargoyles.

5. "Some symbols are great and enduring types, others insignificant and more or less absurd," says T. Tin-

dall Wildridge in *Animals of the Church, in Wood, Stone, and Bronze* (Wymeswold, England: Heart of Albion Press, first published 1898, reprinted 1991), p. 1.

6. Bernard of Clairvaux, in Conrad Rudolf, *The "Things of Greater Importance": Bernard of Clairvaux's Apologia and the Medieval Attitude toward Art* (Philadelphia: University of Pennsylvania Press, 1990), pp. 11–12. For the question of the appropriateness of the use of animals, real and imaginary, in the medieval religious environment, see Janetta Rebold Benton, *The Medieval Menagerie: Animals in the Art of the Middle Ages* (New York: Abbeville Press, 1992), pp. 106–11.

7. These suggestions appear in Lester Burbank Bridaham, *Gargoyles, Chimeres, and the Grotesque in French Gothic Sculpture* (New York: Da Capo Press, 1969), pp. x–xiv.

8. Francis Bligh Bond, *Gothic Architecture in England* (London: B. T. Batsford, 1912), p. 400.

9. See n. 6, above. See also Ronald Sheridan and Anne Ross, *Gargoyles and Grotesques: Paganism in the*

Medieval Church (Boston: New York Graphic Society, 1975), p. 8.

10. Illustrated in Janetta Rebold Benton, "Gargoyles: Animal Imagery and Artistic Individuality," in *Animals in the Middle Ages*, Nona C. Flores, ed. (New York: Garland Press, 1996), fig. 2. Similar barrel-bearing gargoyles are seen on Wells Cathedral, England.

11. Michael Camille, *Image on the Edge: The Margins of Medieval Art* (Cambridge, Mass.: Harvard University Press, 1992), p. 78.

12. These gargoyles may have been automated. See Th. Link, "Der Roman d'Abladane," in *Zeitschrift für romanische Philologie* (Halle, Germany: 1893), pp. 215–32, especially p. 222, lines 9–88; L.-F. Flutre, "Le Roman d'Abladane," *Romania* (Paris) 92 (1971): 458–506, especially p. 478, lines 82–91.

13. See Camille, *Image on the Edge*, and his useful bibliography; the review of this book by Jeffrey F. Hamburger, *Art Bulletin* 75, no. 2 (1993): 319–27; and Nurith Kenaan-Kedar, "The Margins of Society in Marginal Romanesque Sculpture," *Gesta* 31, no. 1 (1992): 15–24. Kenaan-Kedar (*Marginal Sculpture in Medieval France* [Aldershot, England: Scolar Press, 1995], p. 154) cites Hans Reinhardt, *La Cathédrale de Reims: Son Histoire, son architecture, sa sculpture, ses vitraux* (Paris: Presses Universitaires de France, 1963), p. 209, for documents about the repair and restoration work done on Reims Cathedral, including a 1506 document that notes there are "des gargouilles et 'plusiers bestes' du chevet à refaire" (some gargoyles and several monsters on the apse to remake). Kenaan-Kedar writes, "While the subject of the official programme was exactly specified, that of the gargoyles and the *Bestes* remained undefined."

14. For a wealth of examples, see Lilian M. C. Randall, *Images in the Margins of Gothic Manuscripts* (Berkeley: University of California Press, 1966).

15. See Anthony Weir and James Jerman, *Images of Lust: Sexual Carvings on Medieval Churches* (London: B. T. Batsford, 1986); Claude Gaignebet and Jean-Dominique Lajoux, *Art profane et religion populaire au Moyen Age* (Paris: Presses Universitaires de France, 1985); Dr. O. D. Johnton (Henry Joanneton), *Gargouilles* (Troyes, France: Imprimerie de G. Frémont, 1910); and Jurgis Baltrusaitis, *Réveils et prodigues: Le Gothique fantastique* (Paris: Armand Colin, 1960).

16. See Stephen King, *Nightmares in the Sky: Gargoyles and Grotesques* (New York: Viking Studio Books, 1988).

17. The photographs taken by the author were made with a Nikon 2000 camera and a 35–200 mm zoom lens, to which a "doubler" (teleconverter) was added that extends to 400 mm. Small gargoyles and those that are very high up were still out of photographic range.

HUMAN GARGOYLES

1. Nurith Kenaan-Kedar, *Marginal Sculpture in Medieval France* (Aldershot, England: Scolar Press, 1995), pp. 73, 150.

2. Bromyard, in Michael Camille, *Image on the Edge: The Margins of Medieval Art* (Cambridge, Mass.: Harvard University Press, 1992), p. 80.

3. Kenaan-Kedar, *Marginal Sculpture*, p. 72. The ancient Roman architect Vitruvius, in the first chapter

of the first of his *Ten Books on Architecture*, mentions caryatides (statues of clothed women that serve as architectural supports in place of columns) that symbolized the punishment of the people of the city of Carya in the Peloponnesus for their sin of having joined the Persians against their fellow Greeks.

4. Abbé Charles-Auguste Auber, *Histoire et théorie du symbolisme religieux* (Paris: A. Franck, 1870–71), and others have expressed this opinion.

5. In the party game of grimacing, the first person to laugh is the next grimacer. Robert Trubshaw writes, "In the north-west of England, until comparatively recently, face-pulling or 'girning' championships were held where the contestants put their heads through a horse collar and pull the most frightening faces possible." R. N. Trubshaw, *Gargoyles and Grotesque Carvings in Leicestershire and Rutland* (Wymeswold, England: Heart of Albion Press, 1955), p. 3.

6. Claude Gaignebet and Jean-Dominique Lajoux, *Art profane et religion populaire au Moyen Age* (Paris: Presses Universitaires de France, 1985), p. 226.

7. Ronald Sheridan and Anne Ross describe this gargoyle as "crudely erotic" and say, "No doubt his posture is one intended to drive away the ever-present forces of darkness by the power of the exposed sexual organs." (*Gargoyles and Grotesques: Paganism in the Medieval Church* [Boston: New York Graphic Society, 1975], p. 66.)

8. Gaignebet (*Art profane*, pp. 210–15) discusses the "anal offering" and illustrates several corbel figures that present their bare buttocks, calling this "le pet au vilain" ("the fart at the devil"). Gaignebet (p. 215) also notes that *le baiser anal* (the anal kiss)

was an integral part of the reception ritual of masons and cites fifteenth- and sixteenth-century examples. Scatological imagery appears with perhaps surprising frequency in the Middle Ages, most notably in manuscript margins. See Lilian M. C. Randall, *Images in the Margins of Gothic Manuscripts* (Berkeley: University of California Press, 1966), figs. 527–36, for defecating monkeys and men, and exposing and kissing of hindquarters.

9. Gaignebet and Lajoux, *Art profane*, p. 190, fig. on p. 191.

10. See Ugo Nebbia, *La scultura nel Duomo di Milano* (Milan: Edizione Ulrico Hoepli, 1908), pp. 53–82.

11. Illustrated in Lester Burbank Bridaham, *Gargoyles, Chimeres, and the Grotesque in French Gothic Sculpture* (New York: Da Capo Press, 1969), fig. 164.

12. For a fifteenth-century wildman gargoyle on the south portal of the Church of Notre-Dame in Josselin, France, see ibid., fig. 117. A wildman crouches on the Parish Church of Saint Andrew in Heckington, England, and another, wearing a hat, is on the Church of Notre-Dame in L'Epine, France.

13. Joyce E. Salisbury, *The Beast Within: Animals in the Middle Ages* (New York and London: Routledge, 1994), pp. 151–52.

14. Preserved in Hereford Cathedral, England, the *Mappa Mundi*—a single vellum skin measuring 65 by 54 inches—is the only complete extant medieval wall map. Little distinction was made between the actual and the fantastic—the map portrays real animals not known in thirteenth-century England, such as the camel, elephant, crocodile, and rhinoceros, as well as a sort of sphinx, a unicorn, a basilisk (half-bird, half-serpent), a manti-

cora (a human-headed lion), a minotaur (a bull-headed man), a mermaid, a phoenix, and other invented animals. To the medieval mind, all such things were part of the world.

ANIMAL GARGOYLES

1. Illustrated in Janetta Rebold Benton, *The Medieval Menagerie; Animals in the Art of the Middle Ages* (New York: Abbeville Press, 1992), figs. 143 and 144.

2. *The History of Reynard the Fox* and its sequel, *The Shifts of Reynardine*, the son of Reynard, from which the story of the preaching fox comes, were popular in the Middle Ages.

3. Richard Barber, *Bestiary, Being an English Version of the Bodleian Library, Oxford M.S. Bodley 764* (Woodbridge, England: Boydell Press, 1993), p. 76.

4. T. H. White, *The Book of Beasts, Being a Translation from a Latin Bestiary of the Twelfth Century* (New York: Dover Publications, 1984), p. 75.

5. See Horst Woldemar Janson, *Apes and Ape Lore in the Middle Ages and the Renaissance* (London: Warburg Institute, University of London, 1952), and Ptolemy Tompkins, *The Monkey in Art* (New York: Scala Books, 1994), for the many interpretations of the ape.

GROTESQUE GARGOYLES

1. See T. H. White, *The Book of Beasts, Being a Translation from a Latin Bestiary of the Twelfth Century* (New York: Dover Publications, 1984), p. 214 n. 1, pp. 257–59.

2. Dragons carry very different connotations in different cultures and at different times. In the East, rather than being an evil spirit the dragon wards off evil spirits, represents good health, and is associated with creativity and other positive aspects of life.

3. On the confusing history of these terms, see Luther Link, *The Devil: The Archfiend in Art, from the Sixth to the Sixteenth Century* (New York: Harry N. Abrams, 1996), p. 19 f.

4. C. E. Rolt, trans., *Dionysius the Areopagite: On the Divine Names and Mystical Theology* (London: Society for Promoting Christian Knowledge, 1920), p. 127.

5. See Geoffrey Galt Harpham, *On the Grotesque: Strategies of Contradiction in Art and Literature* (Princeton, N.J.: Princeton University Press, 1982), especially pp. 81–86 on the meaning of gargoyles; and T. Tindall Wildridge, *The Grotesque in Church Art* (London: Andrews, 1899).

GARGOYLE SITES TO VISIT

BELGIUM

Bruges: Porters' Lodge (Poortersloge). This late Gothic building served as the meeting place for the burghers of Bruges and, evidently, also gargoyles.

Town Hall (Stadhuis). In addition to the gargoyles on the balustrade, do not miss those high on the tower.

Brussels: Cathedral of Saint-Michel. The many gargoyles include howling demons clutching small people.

Town Hall (Hôtel de Ville). Here is a wonderful array of especially expressive—and grotesque—gargoyles.

Ghent: Belfry (Belfort). There are gargoyles on all levels; ascend the tower to look down on the gargoyles' water troughs.

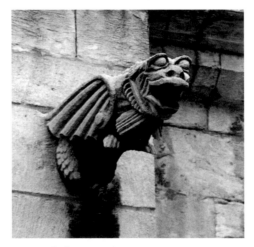

107. Monster with bulging eyes, Town Hall (Hôtel de Ville), Brussels.

Mechelen/Malines: Cathedral of Saint Rumbald (Sint-Romboutskathedraal). An encounter between a monkey and a woman takes place high on the apse end.

ENGLAND

Grantham: Angel and Royal Hotel. On the hotel facade is a gargoyle that appears to be a face when seen from the front, but a defecating man when seen from the right.

Parish Church of Saint Wulfram. The sky shows through some gargoyles' huge open mouths.

Heckington: Parish Church of Saint Andrew. Gargoyles here include a monster grasping a soul, with a boat (the Church) beside them; a wildman; and a man with an ax beside a cow with a worried expression.

Lichfield: Cathedral. There are gargoyles of all species here.

Lincoln: Minster. Do not miss the music-making gargoyles—one plays the bagpipes, another blows a horn.

Oxford: University. Although the many gargoyles on several buildings here are largely restored or modern, a visit to Oxford will not be a disappointment.

Patrington: Church of Saint Patrick. See especially the gargoyles in the form of a laughing monster embracing a woman, and Samson rending the lion's jaw.

Thaxted: Parish Church. In spite of their weathered condition, Thaxted's gargoyles are vividly animated.

Wells: Cathedral. Beware of the men with barrels on their shoulders on the north side of the cathedral.

York: Minster. Among the many gargoyles here, on the south side is a leering devil behind a woman.

FRANCE
Albi: Cathedral of Sainte-Cécile. The gargoyles are seen against the redbrick cathedral.

Autun: Cathedral of Saint-Lazare. Look carefully on the south side for the gargoyle in the form of a defecating man.

Cahors: Church of Sainte-Etienne. A rare siren/harpy gargoyle is on the north side.

L'Epine: Church of Notre-Dame. Easily visible on this tiny gem are a wildman, jester, drunkard, and many others.

Paris: Cathedral of Notre-Dame. A climb up the north tower provides access to a narrow walkway from which gargoyles and grotesques can be seen at eye level. Much here is nineteenth-century restoration work by Eugène Emmanuel Viollet-le-Duc, started in 1845 to repair damage done to the cathedral during the Revolution.
Sainte-Chapelle. The gargoyles are accurately restored.

Poitiers: Cathedral of Saint-Pierre. The west-facade gargoyles are original thirteenth-century work.

Reims: Cathedral. Many of these gargoyles are restored.

Strasbourg: Cathedral. The highly animated gargoyles here are among the most expressive found anywhere.

Toul: Cloister of the Old Cathedral of Saint-Etienne. Within the cloister, the visitor is surrounded by gargoyles.

Villefranche-sur-Saône: Church of Notre-Dame-des-Marais. The antics of the goat and woman take place on the north side.

GERMANY
Cologne: Cathedral. A great many gargoyles, seemingly of every type, appear on all sides.

Freiburg: Cathedral of Our Lady (Münster). The defecating person is on a south side buttress.

ITALY

Milan: Cathedral of Santa Maria. Around the cathedral are the *giganti*—huge figures that support water-spouting figures on their shoulders. Most of these are early-fifteenth-century work, although some are Baroque additions from the first half of the eighteenth century. A small elevator provides access to the roof and a close look at the gargoyles there.

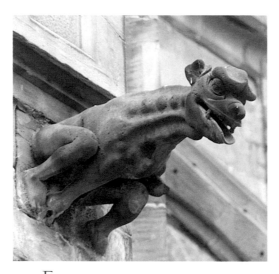

108. *Evil monster, Cathedral of Our Lady (Münster), Freiburg, Germany.*

Venice: Basilica of San Marco. On the upper level are early-fifteenth-century *doccioni*—figures holding vases on their shoulders from which the water issues.

THE NETHERLANDS

Den Bosch (modern name for 's-Hertogenbosch): Cathedral of Saint John (Sint-Janskathedraal). This is the best location in Holland for viewing gargoyles, which date from c. 1500 or the early sixteenth century. A unique feature is the gargoyles that leap out at figures straddling the flying buttresses.

Utrecht: Old Cathedral (Domkerk) and its cloister. The Old Cathedral offers a beast feast, especially on the apse—note the "laughing cow." In the cloister, gargoyles scrutinize the visitor from all sides.

SPAIN

Burgos: Cathedral and its cloister. Here are hybrid animal-human gargoyles.

Acknowledgments

I have the good fortune to have good friends. My thanks go to my academic colleagues, Nona C. Flores and Lawrence Hundersmarck, specialists in medieval literature and medieval religion, respectively, who bravely read drafts of this book and offered many excellent suggestions; to Lauren Jackson-Beck of the Cloisters Library for being chronically helpful; to Adriaan de Roover and Helene Dansker Bergman, who generously permitted me to use their photographs as illustrations; and to those who have joined me on my many travels to find and photograph gargoyles—especially Claudine T. Parisot, Faye B. Harwell, and Robyn and Rolland L'Allier.

At Abbeville Press I have had the pleasure of working with Nancy Grubb, executive editor, whose ideas and clarity of thought greatly improved this book.

I am grateful to Pace University, Pleasantville, New York, for providing financial support for my research.

Above all, the award for assistance (and endurance) goes to my family, especially my husband, Elliot R. Benton.

SELECTED BIBLIOGRAPHY

Benton, Janetta Rebold. *The Medieval Menagerie: Animals in the Art of the Middle Ages.* New York: Abbeville Press, 1992.

———. *Medieval Monsters: Dragons and Fantastic Creatures.* Katonah, N.Y.: Katonah Museum of Art, 1995.

———. "Gargoyles: Animal Imagery and Artistic Individuality," pp. 147–65. In *Animals in the Middle Ages.* Edited by Nona C. Flores. New York: Garland Press, 1996.

Blackwood, John. *Oxford's Gargoyles and Grotesques.* Oxford, England: Charon Press, 1986.

Bridaham, Lester Burbank. *Gargoyles, Chimeres, and the Grotesque in French Gothic Sculpture.* New York: Da Capo Press, 1969.

Brier, Amy. *Gorgeous Gargoyles: Cathedral Stoneworks Celebrates the Alabama Limestone Company in an Exhibition.* New York: Cathedral of Saint John the Divine, 1992.

Camille, Michael. *Image on the Edge: The Margins of Medieval Art.* Cambridge, Mass.: Harvard University Press, 1992.

Cantor, Laurel Masten. *The Gargoyles of Princeton University: A Grotesque Tour of the Campus.* Princeton, N.J.: Princeton University Office of Communications/Publications, 1983.

Farkas, Ann E., Prudence O. Harper, and Evelyn B. Harrison, editors. *Monsters and Demons in the Ancient and Medieval Worlds: Papers Presented in Honor of Edith Porada.* Mainz on Rhine, Germany: Philipp von Zabern, 1987.

Feller, Richard T. *Sculpture and Carving at Washington Cathedral.* Edited by Nancy S. Montgomery. Washington, D.C.: Protestant Episcopal Cathedral Foundation, 1976.

Friedman, John Block. *The Monstrous Races in Medieval Art and Thought*. Cambridge, Mass.: Harvard University Press, 1981.

Gargoyles, Guardians of the Gate. Video. Running time 56 minutes. Washington, D.C.: New River Media, 1995.

Harmon, Robert B. *The Use of Gargoyles in Architecture: A Selected Annotated Bibliography*. Monticello, Ill.: Vance Bibliographies, Architecture Series, Bibliography #A 584, 1981.

Harpham, Geoffrey Galt *On the Grotesque: Strategies of Contradiction in Art and Literature*. Princeton, N.J.: Princeton University Press, 1982.

Kenaan-Kedar, Nurith. *Marginal Sculpture in Medieval France*. Aldershot, England: Scolar Press, 1995.

Link, Luther. *The Devil: The Archfiend in Art, from the Sixth to the Sixteenth Century*. New York: Harry N. Abrams, 1996.

Russell, Jeffrey Burton. *Lucifer: The Devil in the Middle Ages*. Ithaca, N.Y.: Cornell University Press, 1984.

Sheridan, Ronald, and Anne Ross. *Gargoyles and Grotesques: Paganism in the Medieval Church*. Boston: New York Graphic Society, 1975.

Turner, Alice K. *The History of Hell*. New York. Harcourt Brace and Company, 1993.

INDEX

Bold page numbers refer to illustrations.

PHOTOGRAPHY CREDITS

Unless otherwise noted, all photographs were taken by the author.

Art Resource/Alinari: plate 87; Art Resource/Lauros-Giraudon: plate 15; Helene Dansker Bergman, New York: plate 1; LASA, Giraud, Inventaire Général/copyright © SPADEM: plate 83; Photothèque des Musées de Paris/copyright © SPADEM: plate 23; Adriaan de Roover, Antwerp: plates 60, 78, 94; Victoria and Albert Museum, London: plate 86.